Mosaic
Craft

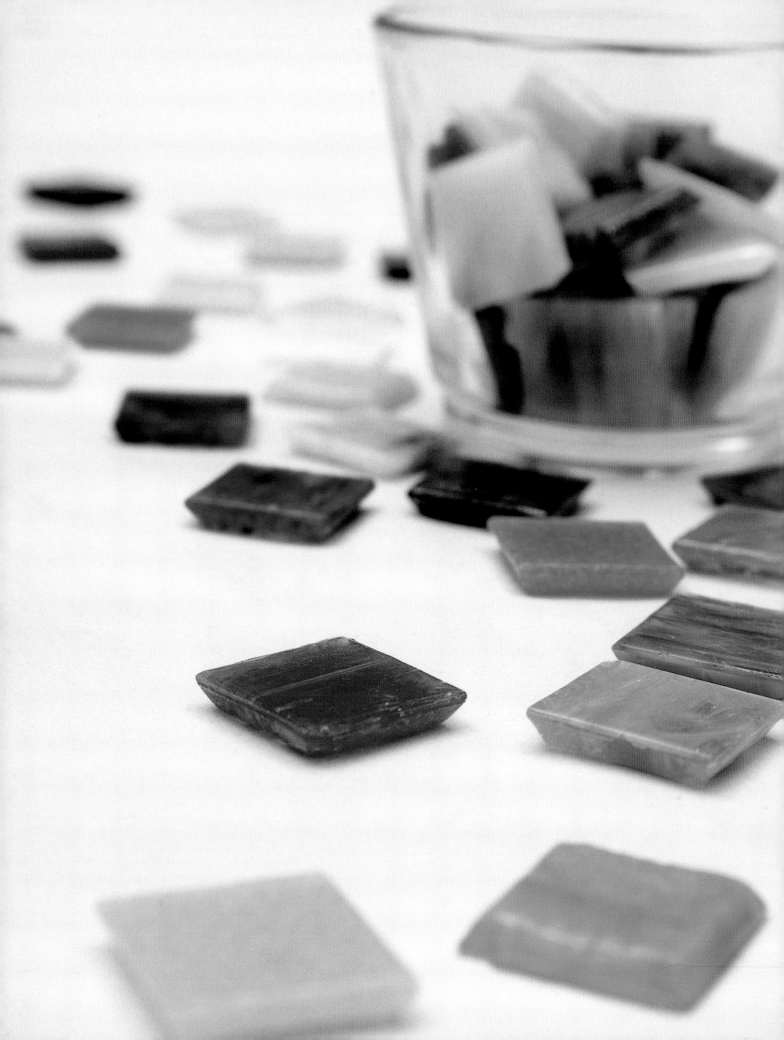

Mosaic Craft

20 Modern Projects for the Contemporary Home

Martin Cheek
with Arendse Plesner

COLLINS & BROWN

To my dad, who loved making mosaics.

First published in the United Kingdom in 2007 by
Collins & Brown
151 Freston Road
London
W10 6TH

An imprint of Anova Books Company Ltd

Commissioning Editor: Michelle Lo
Design Manager: Gemma Wilson
Editor: Marie Clayton
Photographer: Michael Wicks
Designer: The Oak Studio Limited
Senior Production Controller: Morna McPherson
Editorial Assistant: Katie Hudson

ISBN 978-1-843403-760

A CIP catalogue record for this book is available from the
British Library.

10 9 8 7 6 5 4 3 2 1

Reproduction by Anorax
Printed and bound by Craft Print International Ltd,
Singapore

This book can be ordered direct from the publisher.
Contact the marketing department, but try your
bookshop first.

www.anovabooks.com

Contents

Introduction

This book provides a collection of contemporary mosaic projects suitable for the modern home. Since my last step-by-step book was published in 2000, many new materials have entered the craft market. Consequently, a whole variety of new effects can be achieved, which gives rise to exciting and different projects. Those of you who are practised or experienced mosaic artists will want to cut to the chase and go straight to the new techniques and materials, such as the Storm Light on page 60. But do not be alarmed or put off if you have not made mosaics before – we are starting from first principles with a thorough general techniques section, showing you all the basic skills that you need to make your first mosaic.

I have now been mosaicing for over twenty years, and I still enjoy it as much as ever. Mosaicing is both a meditative and relaxing pursuit for me; I treat it as a contemplative process, and I often find that I come up with the idea for my next piece while still working on the current one. One thing leads to another – for instance I have probably made more mosaics of peacocks than of anything else, as it seems to suit both my style and the medium very well. The dozens of peacocks are all different for there was a new reason to make each one. I was a puppet animator, so I am very interested in getting character into my work. With a peacock, for example, showing his pride and dazzling beauty is important – but peacocks are not particularly intelligent birds, so you have to suggest that irony at the same time. I think my background in animation is apparent in my mosaics and to me THE most important things are the flow line of mosaic tesserae and characterization.

That said, I know that to most people the fact that the finished piece should be decorative, usable and easy to make is of primary importance. It is for this reason that I have included a number of attractive practical mosaic projects by the Danish designer and mosaicist Arendse Plesner. Not only does Arendse have a strong sense of pattern and colour, she also – for the first time – introduces the 'glass on glass' method, as seen in the Pendant Lamp on page 52.

You may want to put your finished mosaics in the garden, living room, kitchen, bathroom, child's bedroom… and indeed filling that space in the doorway or bathroom may be your inspiration in the first place! But whether you choose to give your bathroom a makeover with the Dolphin Frieze on page 80, or liven up your kitchen with the Fruit Stools on page 64, I hope that you enjoy the journey and experience of doing this most ancient of crafts.

Happy nibbling!

Martin Cheek

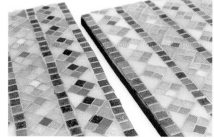
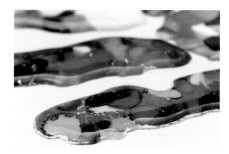

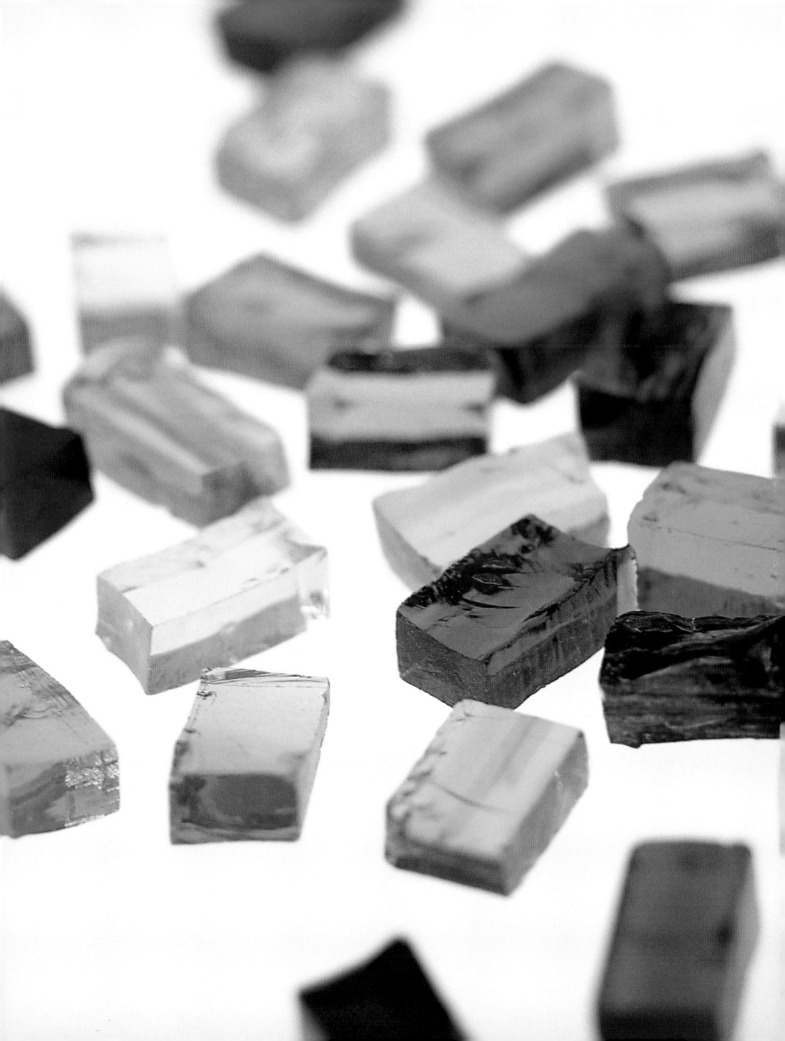

Materials
opaque materials

Mosaic tesserae are traditionally opaque, meaning that the light shines on the surface of the material and reflects off it. There are many different glass recipes, some of which go back centuries. The reds and pinks contain gold in their production, so they are more expensive than any other colours. This is true of any red and pink coloured glass, including stained glass.

A particular challenge to glass making has been to obtain a nice clean purple, but strangely it has still not been possible to achieve that goal. The brownish cloak that you see Jesus wearing in Byzantine mosaics is actually meant be a glorious sacred purple! Even today, with modern scientific methods, glass making remains a rather unpredictable process and it is not always possible to make exactly the same colour from batch to batch.

Name	Size	Traits	colours	Usage	Example
Vitreous glass	2cm (¾in) square	Glass-like, even colour	100 standard colours, but limited variety	Anything	Often used to line swimming pools
Smalti	2 x 1cm (¾ x ⅜in)	Has a flat side and a rippled broken side	Excellent range of rich colours	Flat side up for floors, rippled for texture	Crocodile and Toucan page 115
Roti	Irregular sizes and shapes	The edges and uneven bits of smalti	Rich range of colours	Cheaper than smalti, good for odd shapes	Four Elements page 72
Gold leaf smalti	1–2cm (⅜–¾in) square	Gold leaf sandwiched between glass	20 shades of gold, plus other colours	Metallic highlights and rich reflections	Turkey Toy page 117
Sicis Smalto	1.5cm (⅝in) square	Press-moulded smalti, very regular shape	Very rich colours, plus gold and silver	Excellent when a flat surface is required	Fruit Stools page 64
Sicis Iridium	1.5cm (⅝in) square	Iridescent 'oil on water' effect	Range of Iridescent colours	To add fruity colours	Fruit Stools page 64
Millefiori	From 4mm (³⁄₁₆in) in diameter	Patterned cylinders	Wide range of designs and colours	Great for details and highlights	Jewellery Boxes page 50
Marble	Varies, usually cut to shape and size as required	Natural material, but very heavy	Natural colours	Simple geometric designs	Traditionally used in Roman mosaics
Ceramic tiles and elements	Tiles 2cm (¾in) or 2.5cm (1in) square	Matte unglazed or shiny glazed	Range of subtle colours	Anything	Four Seasons page 110

Vitreous glass

'Vitreous' means glass or glass-like. This material is used to clad swimming pools, so there is a wider choice of blues, greens and whites than of other colours. The tiles are 2 x 2cm (¾ x ¾in), with a flat upper side and a ribbed side to key into the adhesive. They come in sheets of 15 x 15 tiles so to use them for mosaic artworks, soak off the backing paper or mesh in a basin of hot water. Paper is much easier to soak off than mesh. Remove the backing, rinse the tiles in hot water, then spread out to dry on a towel. Store each colour in its own jar so you can quickly find the one you need.

Smalti

Traditionally used to mosaic ancient churches, smalti is renowned for its wonderfully rich range of colours and the magical way that it catches and reflects the light. Smalti tesserae are still handmade in Venice in the traditional way. The glass is melted, poured out onto a metal sheet, pressed flat like a pizza and left to cool. It is then chopped into briquettes. What is unique about smalti is the broken, rippled cut edge, and this is the side you usually position uppermost in mosaics. If you need your mosaic to be flat, then you need to expose the top or bottom of the briquette.

Roti

Any off cuts from the production of smalti briquettes, such as the rounded edge of the 'pizza', and any imperfectly shaped briquettes are called 'roti', which literally means 'broken'. There is nothing wrong with this material – in fact for the first twelve years of my mosaicing career it was all I could afford, as it is much cheaper than the regular briquettes. The roti, being various irregular shapes and sizes, is perfect for modern mosaic. It is possible to get the roti in mixed bags only. The Four Elements by Arendse on page 72 is a particularly good example of how to use these shapes.

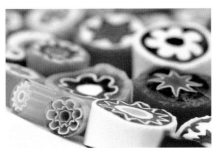

Sicis Smalto

Smalto is mixed to the same recipe as ordinary smalti, but the molten glass is press-moulded into tiles. This gives a much more regular finish, so the tiles are thinner, flatter and excellent for mosaicing and can be used either side up. This is a very exclusive, modern material and although it is expensive a little goes a long way. There are 50 rich colours available, many not available in normal vitreous glass tiles, plus a plain and a rippled effect in both gold and silver. The tiles come on a mesh backing, which is difficult but possible to remove.

Millefiori

Millefiori means 'thousands of flowers' and these are handmade, tiny glass cylinders about 4mm (³⁄₁₆in) high, each containing a flower, circle, star or other pattern. They are made in Murano, a lagoon island near Venice, Italy, and are often fused onto clear glass to make paperweights or jewellery. Millefiori start as thick glass rods, which are stretched into thinner rods of varying diameter and then cut up into tiny cylinders. They are inevitably expensive, but if used sparingly they will go a long way and add beautiful detail to your work.

Marble

Marble is available in white, cream, brown, burnt sienna, blue (rare and expensive), green and black. Most marble for mosaic comes from Italy. Order all the material you need for a job at one time because stone from different areas of the quarry can look very different. To shape marble tesserae use a hammer and hardy, as described on page 14. With marble you need a simple design as the material is dramatic and you can work much bigger as marble is suitable for broader designs. Marble scratches very easily and may need repolishing.

Gold leaf smalti

This precious material was used in the gold mosaic backgrounds of Byzantine churches. The gold leaf smalti is made like a sandwich, with a thick bottom layer of glass, the gold in the middle and a top layer of very thin glass. This top layer protects the gold and prevents it from scratching. Beware of cheap imitation material, which may be gold leaf simply stuck straight onto glass so there is nothing to prevent the gold scratching off. The smalti is then cut into 1cm (3/8in) or 2cm (3/4in) squares. Off cuts are sold as spitzi, which is a mix of various shapes and sizes and is perfect for modern mosaic. There are around 20 different shades of gold smalti, from white gold through to bronze, achieved by using different shades of gold leaf. There is also a rippled version, created by making the top surface of the base layer rippled. You can now also get different colours – green, blue, red, orange and purple – achieved by making the thin top layer in coloured glass. This material can also be used upside down, which I tend to do a lot.

Ceramic

All types of ceramic can be broken up and incorporated into a mosaic, but you can also buy sheets of glazed and unglazed ceramic tiles in various colours. Unglazed ceramic tiles offer a cheap and user-friendly alternative to marble – they come in a subtle range of colours similar to the palette offered by natural stone. I use unglazed ceramic tiles that come in sheets of 14 x 14 tiles, each square measuring 2.5 x 2.5cm (1 x 1in). Also available are smaller tiles 2 x 2cm (3/4 x 3/4in), which match the vitreous glass tiles. Unglazed ceramic tiles don't have a right and wrong side, so you can flip them over if you wish. Vitreous glass is shiny and reflective, while unglazed ceramic tiles are non-reflective and these aesthetic qualities can be used to good effect. Unglazed ceramic is excellent for floor mosaics. I also love making ceramic elements for my mosaics. In Ramsgate Harbour, on page 125, the boats are handmade glazed ceramic pieces.

Sicis Iridium

Iridium glass tiles measure 1.5 x 1.5cm (5/8 x 5/8in) and have a lovely 'oil on water' effect on the surface. The palette of 40 colours is quite subtle and they mix very well with the Sicis Smalto line and Sicis Water Glass line (see pages 9 and 11). An oxide coating added to the tile at the end of the manufacturing process causes the iridescence. It is very durable and like other quality glass tiles the colour will not fade or change. The tiles do vary quite a lot within any given batch, which can be very useful for mosaics as you get subtle shades of the same colour. Like the Smalto range, these are premium quality tiles and therefore expensive, but they offer a unique quality to your work. The Fruit Stools on page 64 are a mixture of Smalto and Iridium.

Translucent
materials

Mosaic tesserae also come in translucent ranges, which allow the light to shine through. There are not many colours available, but they can create great effects – used on a white opaque base they add a wonderful sense of depth. They can also be used to work 'glass on glass' and are excellent for creating lamps without using traditional stained glass techniques.

Name	Size	Traits	colours	Usage	Example
Sicis Water Glass	1.5cm (⅝in) square	Brilliant translucent colours	25 colours, from clear to almost opaque black	Anywhere light will reflect through the tile	Gingham Platter page 40
Millefiori	From 4mm (³⁄₁₆in) diameter	Patterned centre with clear glass edge	Wide range of designs and colours	Details in translucent projects	Tea Time page 124
Smalti	2 x 1cm (¾ x ⅜in)	Has a smooth and a rippled broken side	Good range of translucent colours	Details in translucent projects	Storm Light page 60

Sicis Water Glass

Sicis Water Glass, shown left at the bottom of page 10, is the third line of premium quality Sicis glass tiles (see also Sicis Smalto and Sicis Iridium on pages 9 and 10). The glass used contains a high concentration of natural minerals, such as selenium and cadmium, which produces tiles with very brilliant and clear colours. The Water Glass tiles come in a range of 25 colours, all of which are translucent to some degree, ranging from completely clear to almost opaque black. Most of these colours have a wonderful crackle effect within the tile, which looks fabulous when light shines through it. The individual tiles are 1.5 x 1.5cm (⁵⁄₈ x ⁵⁄₈in) and like other ranges they are supplied in sheets on backing paper, which must be soaked off before they are used in mosaic projects, such as the Pendant Lamp on page 52.

Millefiori

As well as the opaque version, millefiori (see also page 9) come in translucent and semi-translucent varieties. Usually the flower within the little glass cylinder will be made of opaque glass and is then surrounded by a layer of clear glass. Translucent millefiori are not really that see-through, but they are useful as details in items made with the other translucent materials, when working 'glass on glass'. For an example of how they can be used in other projects, see Tea Time on page 124, in which the 'edibility' of the cakes is emphasized by using the sugar-glazed, sweet-shop look of the translucent millefiori.

Translucent smalti

Smalti is traditionally an opaque material so transparent smalti is not real smalti in the truest sense of the word. However, there is a range made of translucent glass cut like smalti that provides a useful addition to the mosaicist's palette. You can use it 'glass on glass' and then shine a light through it, as can be seen in the Storm Light on page 60.

Bases

Many different materials are suitable as the base for your mosaic. Which one you choose will depend on where the final mosaic is going to be situated; interior or exterior. Issues such as weight, thickness – and the cost, for large projects – must also be considered.

WOODEN BASES

All these types of wooden base are available in large sheets or cut to size, and in a selection of thicknesses, from hardware stores. Use 12mm (½in) thick boards for work up to 60cm (24in) square; 2cm (¾in) thick if the piece is larger. For indoor projects seal the wood with a 50/50 mix of PVA diluted with water, for exterior projects use yacht varnish.

MDF (Medium Density Fibreboard)

MDF is a dense, light base board of wood pulp mixed with resin. Normal MDF is not suitable for outdoors, since it is not water-resistant, but there is an exterior version called Medex that is more expensive due to its higher resin content.

Plywood

Plywood is made of sheets of veneer bonded together, with the grain running at right angles in alternate layers. Ordinary plywood is not suitable for outside use, but marine plywood is constructed using waterproof adhesive.

Blockboard

Blockboard is made of strips of softwood, faced on each side with a thin layer of wood veneer, and is much thicker but lighter by area than plywood or MDF. It is usually only suitable for indoor work as the adhesives used in its construction are not waterproof.

LIGHTWEIGHT BASES

Mosaic is heavy and there are situations where you will want a lightweight base board to avoid adding more weight to a piece.

Wedi board

This is a lightweight board designed for tiling with a Styrofoam core and a polymer-cement coating reinforced with glass fibre. It is waterproof, easy to cut and very stable.

Hexlite

Hexlite is a rigid, strong, flat, ready-made, aluminium honeycomb panel used extensively in the aircraft industry because of its extreme rigidity and strength. It is excellent for mosaics because it is stable and light.

Mesh

Mosaic mesh comes in rolls and can be cut to the size you need with sharp heavy-duty scissors. With mesh you can make alterations before the piece is installed by pushing out the wrong colour tiles by hand and replacing them. You can also work close up on a detail and then incorporate it into a larger piece, or make mosaic motifs to replace tiles in your kitchen or bathroom.

THREE-DIMENSIONAL BASES

Three-dimensional bases are slightly more complex but allow you to make a much wider range of projects.

Metal

A selection of metal bases ready for mosaic panels is available from larger craft suppliers. They include simple trays, trivets, table bases, shelves and even garden chairs.

Glass

Simple glass shapes that can be lit from inside or behind are ideal. A range of plain lamps, vases and dishes is available from stores such as IKEA.

Glazed ceramic

Mosaic has been applied to unglazed sealed terracotta pots for many years, but with the introduction of silicone adhesives and translucent tiles, glazed ceramic items can now also be used as bases. The underlying gloss of the surface will reflect light back through the mosaic design.

Adhesives
& grout

There is a wide range of adhesives and grout available, but your selection will be influenced by where the final piece of work will be situated. There is a big difference between water-resistant, waterproof and frost-proof products – only use frost-proof materials for exterior mosaics.

PVA (Polyvinyl Acetate)

This is the standard adhesive used when making a direct mosaic. For indoor use PVA is perfect and is very user-friendly – it washes off your hands easily with soap and water and has no harmful odours. When wet it is white, but as it sets it turns clear. Once set, the bond is very strong – as anyone who has tried to correct mistakes by ripping up glued-down tesserae can testify.

Epoxy resin

For outdoor repairs, or if a stronger adhesive than PVA is required, epoxy resin is the answer. It is available from hardware and department stores and comes in tube or syringe versions, with two parts that must be mixed together thoroughly. Quick setting epoxy resin has a working time of about 5 minutes and a setting time of about 15 minutes. Slow setting epoxy resin has a working time of about an hour and a setting time of about 16 hours.

Silicone

Silicone adhesive is used for 'glass on glass' projects. It comes in tubes – the smallest is around 50ml, which will be enough for several projects. Always work with silicone in a well-ventilated environment and avoid getting it on your fingers as it is difficult to remove. Silicone has a working time of 5–10 minutes, sets after 30 minutes and has properly cured after 12 hours. Make sure you replace the top on the tube or it will be rendered unusable.

Tile adhesive

For most projects an 'all in one' tile adhesive and grout, suitable for indoor and outdoor use, is perfectly adequate and is available from most hardware stores. When mixing the adhesive, always make sure that you read and follow the instructions carefully.

BAL Flex

BAL Flex is a trade name for a flexible thin- or thick-bed adhesive suitable for interior and exterior. It is rubber based, and can be used for wet areas, for tiles subject to vibration and for wooden floors. It is a two part adhesive; there is a bag of powder and a bottle of liquid latex. When set it becomes a strong latex sheet, a bit like a carpet. BAL Fastflex, as the name suggests, is a faster setting version. Both are available in grey or white; I recommend the white as it allows the luminosity of the tesserae to shine through.

Adhesive film

Rolls of sticky-back adhesive film are available from stationery stores – it is mainly used as a protective coating for documents but is ideal for indirect mosaics. The tesserae stick well to the film, but will not hold up to constant repositioning so work out any fiddly areas on the side first. Don't cut tiles over the film as this creates dust and splinters on the sticky surface. When finished, allow the mosaic to 'sink in' to the adhesive for 24 hours before setting it.

Grout

Powdered grout is available in grey, white, ivory and brown, and ready-mixed grout in a variety of colours. Ready-mixed grout has a shorter shelf life – although this can be improved by covering the surface of the grout left in the pot. Powdered grout can be coloured by adding coloured powder pigments or textured by adding up to 50% fine builder's sand. I recommend plain grey grout, because it delineates the tesserae and brightly coloured lines can overpower the design. Use exterior grout for outside or for places that may get wet, such as a bathroom splashback. Epoxy grout is a version for floor areas with a lot of traffic. Always follow the health and safety instructions on the packet and wear rubber gloves when grouting.

Tools

You require very few specialist tools for mosaic work – most of the items may already be in your tool box, or can easily be found in local hardware or craft stores.

Nippers

Mosaic nippers are available in two standard forms: wheeled nippers and side-biter nippers. In both cases, the pivot point is high and the handles curve in towards the bottom, where you are meant to hold them. This combination of features gives the nippers maximum leverage, so you do not have to work hard to cut the tiles. The handles are sprung so you do not have to pull them apart each time you cut a tile. When closed the cutting edges don't quite touch – this is correct as you only need to crack the tiles and it vastly increases the life of the tool.

Wheeled nippers

This tool is good for cutting wedges, narrow strips and for precision cutting in general. It works very well when cutting dense high-quality glass such as smalti. An Allen key is provided so that you can spin the wheels when they get worn.

Side-biter nippers

These cut at right angles to the handles and are good for cutting circles and for general cutting. The jaws of the nippers are made of tungsten carbide for strength. One side juts out; this is the side that you use to cut tiles in straight lines. For a straight cut, put the jaws around 1cm (³⁄₈in) into the tile. For 'nibbling', place the tesserae into the middle of the jaws. Use the jaws the other way round – facing outwards away from the tile – to cut curved lines.

Hammer and hardy

This is used to cut material into smaller or thinner pieces. The hardy is held firmly embedded in concrete or wood, leaving both hands free to control the material you are cutting. A special hammer and hardy, with tungsten-tipped fine edges, is used for cutting glass such as smalti. It is much more expensive than the version for cutting natural stone – so if you have one don't use it on stone as it will quickly ruin the tip and drastically reduce the life of both hammer and hardy.

Tweezers

A pair of tweezers can be used to pick up very small pieces, or to 'tweak' the tesserae. The longer the tweezers are, the easier they will be for you to use.

Colour wheel

You can make a colour wheel by cutting up paint sample cards – the process makes you think about colour choices.

Brushes

A big paintbrush is useful to keep your working area clean. Smaller paintbrushes can be used to paint the edges of the finished mosaic – it is not a good idea to mosaic the edge of the board as the tiles here will get a great deal of wear and may fall off. Match the paint to a suitable colour in the design, or just use black. A short, stiff brush is ideal to clean semi-dry grout off the surface of the tiles.

Cutting knife

A sharp knife – with a retractable blade for safety – to cut adhesive film and mesh.

Builder's float

A builder's float is a flat piece of wood with a handle on one side, used to smooth or flatten adhesive, or to spread grout over large areas.

Grout spreader and sponge

Standard size grout spreaders from a building supply or hardware store are fine. Larger areas are quicker to grout with a large size, but for very small pieces you can use an old credit card. A sponge is handy to work grout into small lines and for cleaning the finished piece.

Bradawl

This is metal tool with a fine pointed end, useful to scrape out excess adhesive and generally tidy up.

Apron

Wear an apron, because when you are cutting pieces can fly off – if they land in your apron you can retrieve them easily.

Gloves

Always use rubber gloves when working with grout and adhesives.

Face mask and goggles

Always wear a face mask when using grout and goggles when cutting glass.

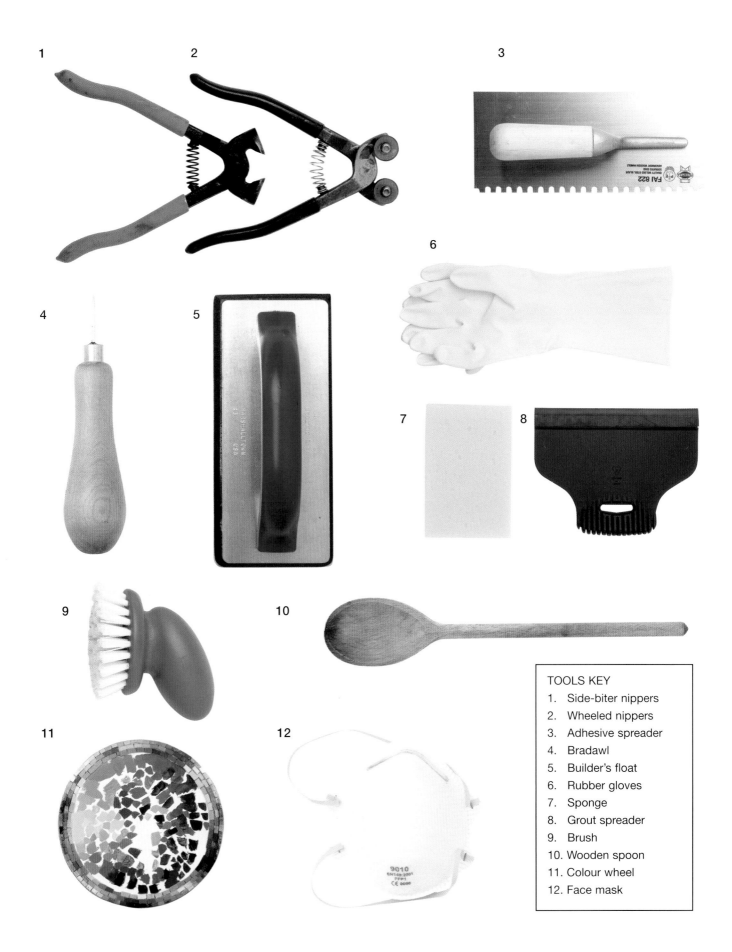

1

2

3

4

5

6

7

8

9

10

11

12

TOOLS KEY
1. Side-biter nippers
2. Wheeled nippers
3. Adhesive spreader
4. Bradawl
5. Builder's float
6. Rubber gloves
7. Sponge
8. Grout spreader
9. Brush
10. Wooden spoon
11. Colour wheel
12. Face mask

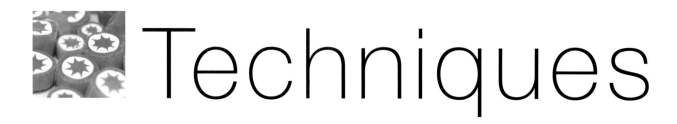# Techniques

While choosing your subject is down to personal taste, certain motifs lend themselves to mosaic. A reptile or a fish has scales, so it already looks like a mosaic and you are giving yourself a head start. Simple designs tend to work best, as mosaic is essentially a bold medium and its subject is stylized. Historically, micro-mosaics emulating realism have been popular, but for me this is a pointless exercise – while one gasps in admiration at the technical skill, to my mind they are mosaics that wish they were paintings!

Choosing your materials

A really important decision to make right at the start is whether your finished mosaic will be kept indoors or outdoors, as this will affect the materials, base and adhesive that you can use. Another important factor is whether the mosaic surface needs to be flat or not – a table top or a chair seat needs to be smooth, so clearly the rippled surface of smalti would not be a good choice for these projects.

I often find that the materials themselves give me ideas – for instance, when people first see millefiori a common reaction is to say it looks like sweets. So if you make a mosaic with it that looks like cakes or sweets, as in the Tea Time project on page 124, you are already halfway there as you are working with the nature of the material rather than

against it. Another example is the Sicis Iridium – I thought it looked very luscious and fruity, which was my inspiration for the Fruit Stools on page 64. Of course you could make the same design in vitreous glass, but it would not look as good because it would look flat and wouldn't zing out. It is the iridescent quality of the Sicis Iridium that makes it look fruity in the first place.

Choosing different materials for the subject and background will add to the contrast of your finished mosaic – for example see Four Seasons on page 110, which has a smalti pheasant next to a flat ceramic landscape. The highly reflective quality of the glass will visually come forward leaving the non-reflective unglazed ceramic to push back.

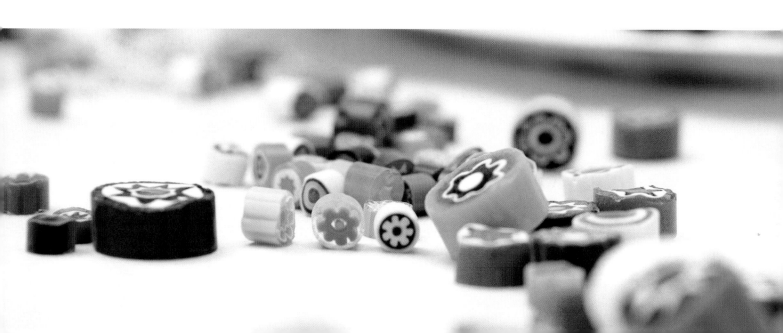

Selecting a palette: colours and tones

Your choice of colour palette will affect the look of your final piece the most. When choosing your colours, you need to ask yourself certain questions, such as whether the mosaic needs to coordinate with the decor of the room, or whether it should stand out and look different? Do you want contrast or harmony? Choosing a palette of natural stones with their subtle colour combinations will give a different effect from choosing the bright range of colours offered by using vitreous glass or smalti. Limiting your palette is also a good way of creating harmony; one or two carefully chosen colours can have a greater impact than the use of every colour available!

In any case, a colour wheel is a very useful tool. If you choose colours close to each other on the wheel, the effect will be harmonious. For a bolder effect, choose bright clean colours opposite one another – yellow and purple or red with green. A good way of checking out unusual contrasting colour combinations is to look at the Art Deco period, when this use of colour was in vogue – for example in wallpaper design.

The tone of a colour is an important consideration. Pastel colours work well together, because the content of white in the pastel shades is the dominant element. A good way of considering the tone of a certain colour is to imagine it in a black and white photocopy. What shade of grey will it be? When we say that tonally two colours are the same, we mean that they would come out the same shade of grey. Thus two very different colours, blue and orange for example, can be tonally the same. The greater the difference in tone between two areas, the greater the overall contrast will be.

Laying the tesserae

The lines created by the various rows of tesserae are what give the finished mosaic its movement. Curved lines can give a great sense of movement – Van Gogh's painting *Starry Night* is a perfect example of this – while straight lines offer a calmer, slower feel. When mosaicing your motif, allow the *opus* to describe the form. In the case of a tiger, the stripes on his back are markings and have nothing to do with the form. So in order to mosaic a tiger in such a way as to describe his form, you should run the tesserae along his back and down his legs alternating the black and orange tesserae as you go.

You should consider how you are going to cover the area and the layout of the tesserae covering the background – they can be in regular horizontal lines (*opus regulatum*) such as seen in the Cephalopods on page 122, or follow the lines of the motif (*opus musivum*) such as in the Corn Fed Chicken on page 119. Each will bring its own unique feel to the piece.

Another thing to consider is the *opus vermiculatum* – the outline in the background colour that goes round the subject, like a halo or a bumper on a car, to stop the background visually colliding with the motif. The line round the octopus in Cephalopods is a really good example of how the *opus vermiculatum* acts like a bumper, protecting the motif from the straight lines of the background that would otherwise just crash into it. As a general rule, keep the *opus vermiculatum* clean – if you are going to pepper your background with different colours, it is best not to have any peppering in the *opus vermiculatum*, as it destroys the unity of the line. However, be aware of what is happening in the background and use your discretion. Remember that the *opus vermiculatum* will delineate your subject and make it stand out from the background but in some instances this may not be what you want in your design.

Where to begin

When considering the time required or the skill level involved to complete a project, remember that larger mosaics are often easier to make than smaller ones, as you can use the mosaic pieces at their original size, so there is less cutting involved. It is also more fiddly and time-consuming to work with small pieces and to grout the finished item. With large pieces you can often cover a large area quickly, although this does depend on the complexity of the design.

Before you start

If you are a beginner, the temptation is to start on the centre of the design first. In fact there are two good reasons why it is best to start on the border. Firstly, you will get useful practice at cutting the tiles into tesserae. If a tile accidentally cuts at an angle that isn't straight, you can compensate by cutting another to match this angle. You will also soon find that it is a lot easier to mosaic next to tesserae that have already set. If you are working on a very precise area, such as a face for instance, it is a good idea to place the eye in position and let it set. Then when you work on the face later, there is no possibility of the eye being disturbed.

As a general rule, establish what the key line of your motif is; the line of action that gives your subject its pose. For example, in the Corn Fed Chicken on page 119, this is the curved line that runs from the bird's beak to his tail. Mosaic this key line first. It is worth paying attention to detail and getting this line particularly clean and neat, as this will establish the generic movement for the entire piece. Always mosaic the object that is closest to you in visual terms. If you are mosaicing a picture of a fish swimming through seaweed, the nearest seaweed that comes in front of the fish needs to be worked on first, then the fish itself, then the seaweed behind the fish and finally the watery background.

ⓘ Health & safety instructions

- Always wear safety goggles and a face mask

- When you are cutting the tiles, don't allow anyone to come near you, unless they are also wearing mask and eye protection

- When using adhesives such as silicone adhesive, work in a well-ventilated area

- Use a dust pan and brush to sweep up the glass shards – never use your hands

- Keep your work surfaces clean at all times – sweep up or vacuum after each session

- Keep glass particles away from food and drink, children and pets

- When cutting tiles, you may choose to work with your hands, nippers and tiles inside a clear plastic bag or a bucket to keep all the glass waste under control

- Read and follow the manufacturer's instructions on all adhesives and grouts

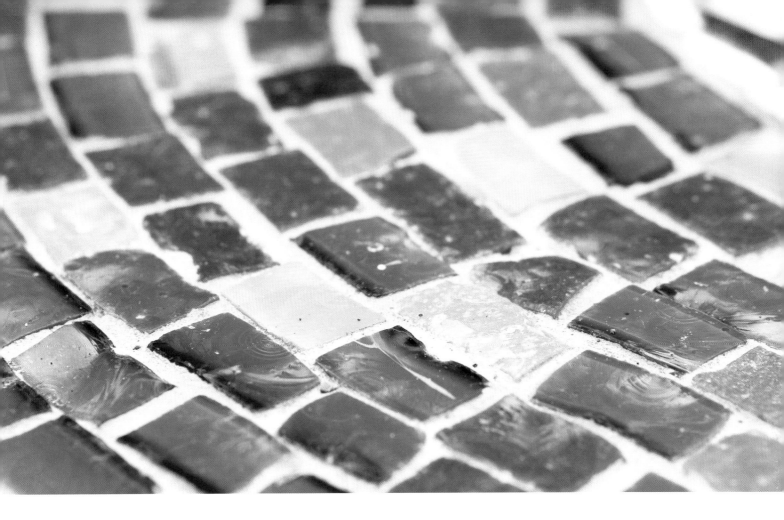

Gaps between tesserae

I am often asked about the gaps between the tesserae – should they be big or small? Personally my work is very tight, so I don't have much gap. I find gaps a problem in my own work because of my obsessive nature, but others find it difficult to work as tightly as I do. Don't fight your nature – if you end up with big gaps, you will know yourself if this is acceptable to you.

Whatever the style of your work, attention to detail is vitally important and will show in the finished work. If you take your time and give your mosaic care and attention, this will pay off. I find tightness and neatness essential for my own work, but others do not, preferring a looser approach. Follow your personal style – although you may need to make a few mosaics before you know what that style is!

Mind the gap

The gaps between the tesserae and the resultant grout lines can be turned into a design feature and varied to give different effects. When you need to show a very thin line, such as a fishing line or a butterfly's antennae, leave a controlled, neatly drawn gap where the adjacent tesserae meet.

Transferring the design onto a board

Templates have been included for all the projects that need them and these can be enlarged on a photocopier to the correct size. Place a piece of carbon paper on top of your board, lay the template on top and draw over it with a hard pencil to transfer the design onto the board.

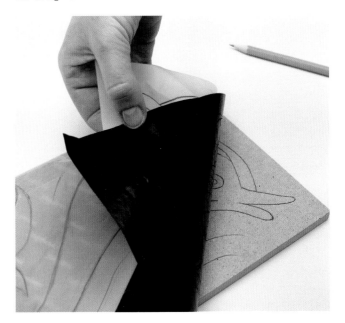

Cutting

A vitreous glass tile measures 2 x 2cm (³/₄ x ³/₄in), but many projects will need smaller elements. You can cut each tile into quarters, each of which will average 1 x 1cm (³/₈ x ³/₈in) – although you will soon find that it is impossible to cut all of the tesserae into perfect squares. Don't worry about this, because it is the slightly different shapes that will give your mosaics a handmade quality. Remember that mosaic is an ancient craft that peaked many centuries ago; we are not trying to make anything that looks as though it has been made by a machine! These ¹/₄-tile 1 x 1cm (³/₈ x ³/₈in) tesserae are the basic units that we will be working with in many of the projects in this book. Any smaller than this and it tends to get too fiddly.

You may also need to cut tiles into triangles, circles or irregular shapes. Again, these will not be perfect, but it is the uneven shapes and sizes that will make your work unique.

Quarter tile tesserae
Using the wheeled nippers, put the jaws in the middle of the tile you want to cut, secure it, closing your other hand around the nippers as you cut to prevent pieces flying away. Cut the piece in half, then cut in half again.

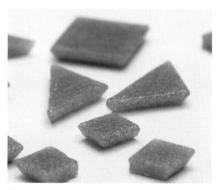

Triangles
Use the wheeled nippers – which give you more control – to cut tiles on the diagonal to make triangles. Again, hold the tile between your thumb and index finger, with your hand cupped around it.

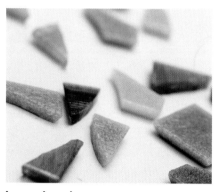

Irregular shapes
To cut irregular shapes for a 'crazy paving' effect, place the wheeled nippers across the square tile at an angle about a third of the way in and cut. Cut the large piece roughly in half again at an angle, to get three irregular pieces.

Circles
To make circles, nip the four corners off the tile to make an octagon, then carry on moving around the shape, nibbling off any projecting points until you have completed a circle.

Wedge shapes
When you want to mosaic a curved line the tiles will need to be wedge-shaped. Trim one side at a slight angle to create a trapezoid shape.

Frieze frame

If you are making a frieze, draw up the motif template on tracing paper so you can reverse it and make the same motif running in opposite directions. Most computer photo processing programs allow you to scan in your own design and blow it up or flip it. If you do not have this facility, your local copy shop will be able to do this for you.

Following a design

Once you've purchased your tiles and selected a design, you can begin your mosaicing, which is incredibly rewarding and enjoyable. Be sure to follow the design techniques here for working in straight and curved lines to avoid any disappointment in the end!

Mosaicing a straight line of tesserae

Draw a straight line with a pencil and try to mosaic a line of tesserae along it. You will find that it is a bit like steering a car – if you are slightly out at the beginning you don't notice, but 100 yards further down the road you are driving on the wrong side! Try and keep to the line by choosing each successive tessera so that the angle between the line and the previous tessera is the same. As well as the line you are working to, it is equally important to leave yourself a straight line for the next row of tesserae, so you need to think ahead. If a piece looks good next to its neighbours but sticks out a little more, nibble it down to the same width before you fix it in position. Alternatively, you can correct things on the next row by placing a thinner tessera next to it, putting yourself back on course – if you don't sort it out quickly, you may find things getting progressively worse with each subsequent row.

Mosaicing a curved line of tesserae

If you put a series of squares together you will get a straight line, so to go in a curve you need to cut the tesserae into wedges by taking a slight diagonal off one side. Lay them down with the right angle next to an acute angle each time to create the curve. If you find you are curving too much, put a square tessera down to compensate, then start cutting wedges again. When you are working in concentric circles, such as on the Fruit Stools on page 64, the angle of the wedge becomes more acute as you move towards the centre, so you may have to cut an angle on both sides of the tesserae to get the pieces to fit.

Square deal
If you want perfect squares, you will either have to buy smaller tiles or use the standard size and work at a bigger scale.

Direct mosaic

There are two basic methods of making a mosaic – direct and indirect. With direct mosaic the tesserae are glued directly onto the surface that you are mosaicing. The pieces are placed the right way up, the uppermost surface becoming the final surface of the finished mosaic. The advantage of working direct is that you can see what you are getting at all stages of the creative process. The disadvantage of direct mosaic is that the final surface is not completely flat, so it is therefore not suitable for floors or items like a table top or chair seat.

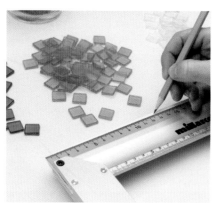

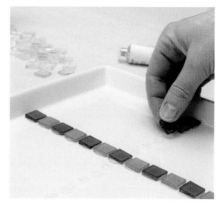

1 The Gingham Platter on page 40 is used here to illustrate the direct technique. Measure the sides and mark the mid point of the gingham pattern high up on each side. Do not draw a line between the marks across the base, because you will be able to see it through the translucent tiles and will not be able to rub it out later.

2 Dot one spot of silicone for each tile along the central lines between the marked points to establish key lines to work to.

3 The final layer of silicone should be about 1mm ($\frac{1}{16}$in) thick beneath the tiles – you should not be touching glass to glass but also you should not have silicone coming up at the sides of the tiles. Use a plastic knife or a piece of glass to remove any excess silicone; getting the correct amount of silicone on the base and not on your fingers is the key to a clean and lasting result.

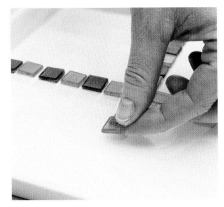

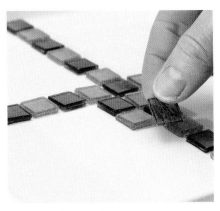

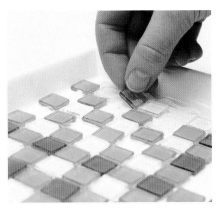

4 The first two lines of tiles are laid at right angles to each other between the mid points marked on each side of the platter. These are the key lines for the design, so adjust them as required to make sure they are straight and to even up any gaps.

5 Start filling in the gingham pattern between the key lines, one quarter at a time. Again, place a dot of adhesive for each tile, working across an area of the base you estimate you are able to finish in about 5–10 minutes.

6 Tweak the tiles as you work to get a neat pattern. Leave the finished platter to allow the silicone to cure before grouting. The silicone will set after 30 minutes and is fully cured after 12 hours.

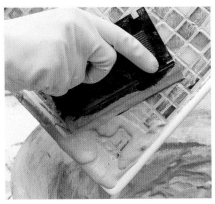

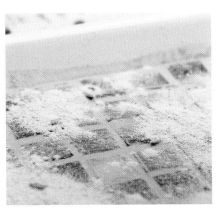

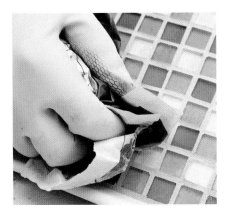

7 Apply the grout by placing a good dollop on the platter and then go over it with a grout spreader, smoothing it in all directions so it is pushed into all the gaps. Scrape the excess off into your grout mixing bowl.

8 Sprinkle a layer of dry grout over the platter and leave it to absorb the moisture for 10–20 minutes.

9 When you can see the pattern of your mosaic coming through, wipe off the excess grout with dry newspaper. Continue wiping until the tiles are clean and sparkling.

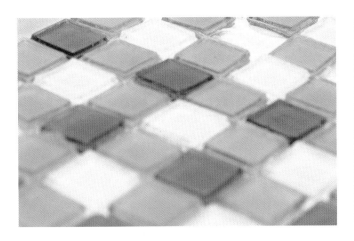

Base models

Working direct on a wooden, glass, or a glazed base is the quickest way to get a finished result. You can lay your design out at the side of your work to check the fit and see the effect of different colours before you fix the tesserae into place. Making a template on squared or graph paper can be very helpful. Here we show working direct on a base using the Gingham Platter (see page 40), which is a simple and traditional geometric pattern ideally suited for your first mosaic.

Working on mesh

Working directly on mesh allows you to make alterations, or incorporate smaller elements into a larger piece. The Dolphin Frieze on page 80 demonstrates the flexibility of working with mesh. Here we show the mesh method on one of the main motifs from the frieze.

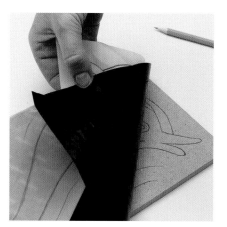

1 Place a piece of carbon paper on top of a piece of MDF, lay the template on top and draw over it with a hard pencil to transfer the design onto a suitable base board.

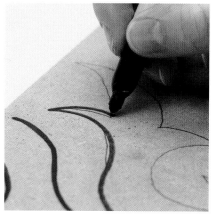

2 Draw over the lines of the design on the board with a black felt tip pen, so you will be able to see it clearly through the mesh.

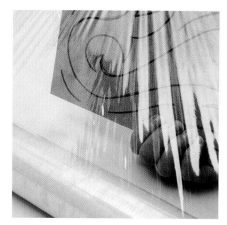

3 If you cover the base board in cling film the mesh will not stick to it, so if you are making many repeat motifs you can use the same board over again. Take a large piece of cling film, pull it tightly over the board and tape it securely to the reverse side.

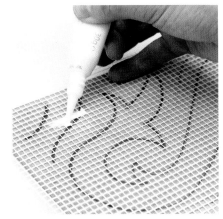

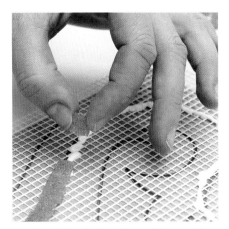

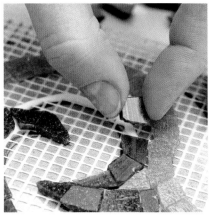

4 Cut a piece of mesh around 1cm (³⁄₈in) larger all around than the size of the motif. Place the mesh over the motif, then smudge a few spots of adhesive in the background areas to hold the mesh in place. Draw over the design onto the mesh itself with a marker pen, simplifying the shapes and lines if necessary.

5 Look for the key lines of the motif – there is usually one line, or sometimes two or three, that set the shape of the design. These are the first lines you work on and it is worth spending time getting them nice and neat, as they will set the rest of the design. Dab a small spot of PVA to the back of each tessera and stick them down one by one. As you become more confident, you can run a thin bead of PVA along the next line prior to mosaicing it.

6 Start filling in the design, working outwards from the key lines.

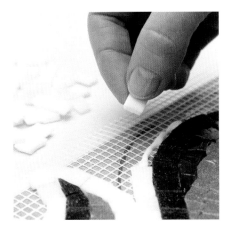

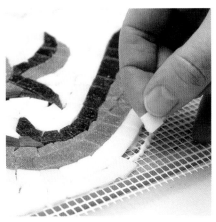

7 Establish the background's *opus vermiculatum* – the outline of the background that goes around the subject to stop the background visually colliding with the motif.

8 Start filling in the background, working in lines that follow or complement the shape of the dolphin.

9 Leave the finished piece to dry overnight, until it is stable with the pieces held firmly in place. The following day, peel off the finished motif carefully and turn it over to dry thoroughly.

Changing design on mesh

To change an area of the mosaic, carefully bend the mesh to loosen the row or patch of tiles you want to remove. Then lever them out with your fingers or a sharp tool. You can now replace them with another colour.

Indirect mosaic

If you look at a sheet of mosaic tiles straight from the manufacturer, you will see that the tiles are spaced apart in a regular grid on the backing paper – or more recently, to adhesive film. The finished face of the tile is the one stuck down to the backing and the reverse – the outer face that you can see – may be ribbed to allow adhesive or cement to stick. At the fixing stage, the sheets are 'buttered' with cement on the ribbed side and applied to a rendered wall. When dry, the backing, which is now the top surface, can be soaked or peeled off and the tiles grouted. This is the basic principle of an indirect mosaic.

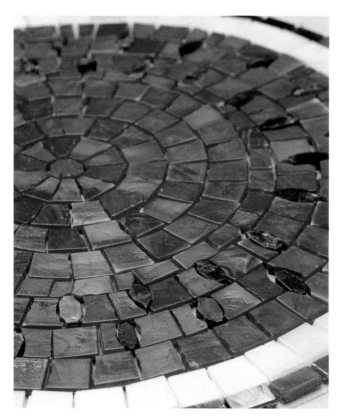

When a smooth, flat finish is required, for a floor, table top, or chair seat for example, the mosaic needs to be made indirect. The other advantage of working indirect is that the mosaic artist can work at home in his warm studio, instead of having to travel and work on site. When set into cement or concrete an indirect mosaic is suitable for external use and will last not just a lifetime, but – if the Roman mosaics are anything to go by – for centuries to come.

When you are working indirect, be aware of both sides of the material. The surface you are seeing as you work is the underside – it will be hidden when the piece is finally installed. Make sure you place pieces with the best side downwards – they may have nice veining on one side, but not on the other, or a cut piece may look like a perfect circle on one side, but is rough on the other. The indirect method is shown here using a Fruit Stool (see page 64) as our example.

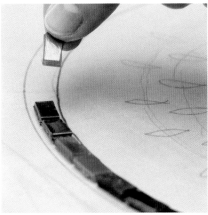

1 Cut a piece of adhesive film 3cm (1¼in) larger all around than the motif area. Centre it over the motif, sticky-side up, peel back 5cm (2in) of the backing paper and tape the edge down across the top of a wooden base. Now stick down the opposite side and then the two remaining edges. The final surface should be nice and flat with no wrinkles. When you are ready to start mosaicing, peel off the backing paper. Retain it so that you can protect the sticky surface between mosaic sessions.

2 Establish the key line of the watermelon by working around the outside edge in the dark green half tiles to make the rind. Set the tiles 3mm (⅛in) in from the edge line, so the final mosaic will not overhang the top of the stool. Make sure you place the smooth machine-finished edge of each tile along the outside edge – not a side you have cut, which may be sharp.

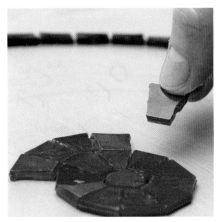

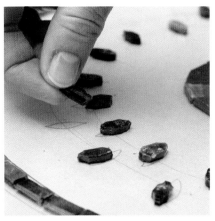

3 Establish the true centre of the stool and place the central circular tile right in the middle. Work outwards for two more rows to create the central core of the fruit.

4 Place the seeds in two rows, making them a little bit irregular in shape and positioning for a more natural effect.

Indirectly...

- Remember that with indirect mosaic you are working with the tesserae upside down, so once set the design will be reversed. This is particularly important if letters are involved – you need to work on a mirror-image of your design so they will be the correct way round at the end.

- Before starting to lay tesserae, it is a good idea to cut up a handful of tiles and build up a small reservoir to choose from. If you place each colour on a separate paper plate, then not only will you be able to move each colour closer when you need it, but clearing away will also be made easier as you can simply pour the tesserae back into the jar.

- If the mosaic is a large one and will need to be cut into smaller sections so that you can manageably fix it, draw a series of horizontal and vertical wavy lines on the back of the paper to act as registration marks later. It also helps to number your grid in rows: A1, A2, A3, B1, B2, B3, etc.

- If you need to divide the mosaic into sections then remember to allow a wide enough gap to run a scalpel through the plastic.

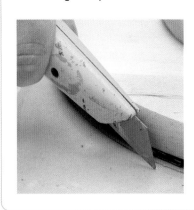

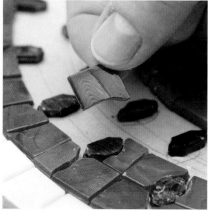

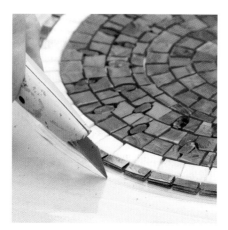

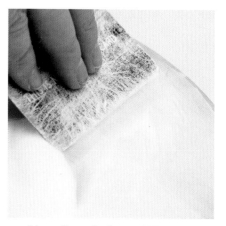

5 Start filling in the design, working in towards the centre in concentric rows and cutting the tesserae as required, making the circles fit around the seeds. Continue until you have completed the fruit. Leave the finished motif to settle overnight, as the tesserae will stick more firmly to the adhesive film over this time.

6 To release the mosaic from the board, use a sharp knife to cut through the adhesive film all around the motif. The mosaic is now ready for you to lift it carefully off and position onto the glued surface.

7 You will need a layer of PVA adhesive about 1mm (¹⁄₁₆in) thick across the entire top of the stool. Make sure that the area at the edges is well covered, as the tiles here are more likely to come loose if not firmly stuck. Pour a good dollop of PVA onto the surface of the stool, then spread it across the whole area with a grout spreader or a piece of flexible plastic – an old credit card is ideal.

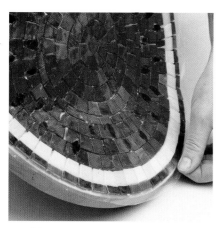

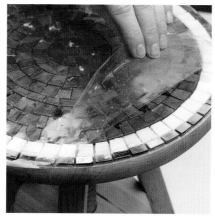

8 Place the motif with the plastic side upwards on the stool, checking all around to make sure it is perfectly centred. Press it down firmly all over the top of the stool, and leave to dry overnight.

9 The next day carefully peel off the plastic – don't just rip it off vertically, ease it back onto itself a little at a time in case any of the tesserae are not thoroughly fixed. Leave the stool for another few hours to completely dry before it is ready for grouting.

In design

- Remember that when you are working indirect it is the surface of the tile you are placing downwards that will be seen in the final design. Make sure that this is the best side.

- Work out fiddly bits of the design on the side before you place them on the adhesive film. You will only be able to move things around a limited number of times, before the film will lose its stick.

- Don't cut tiles near the film – bits of dust and splinters will stick to the sticky surface and will be impossible to remove.

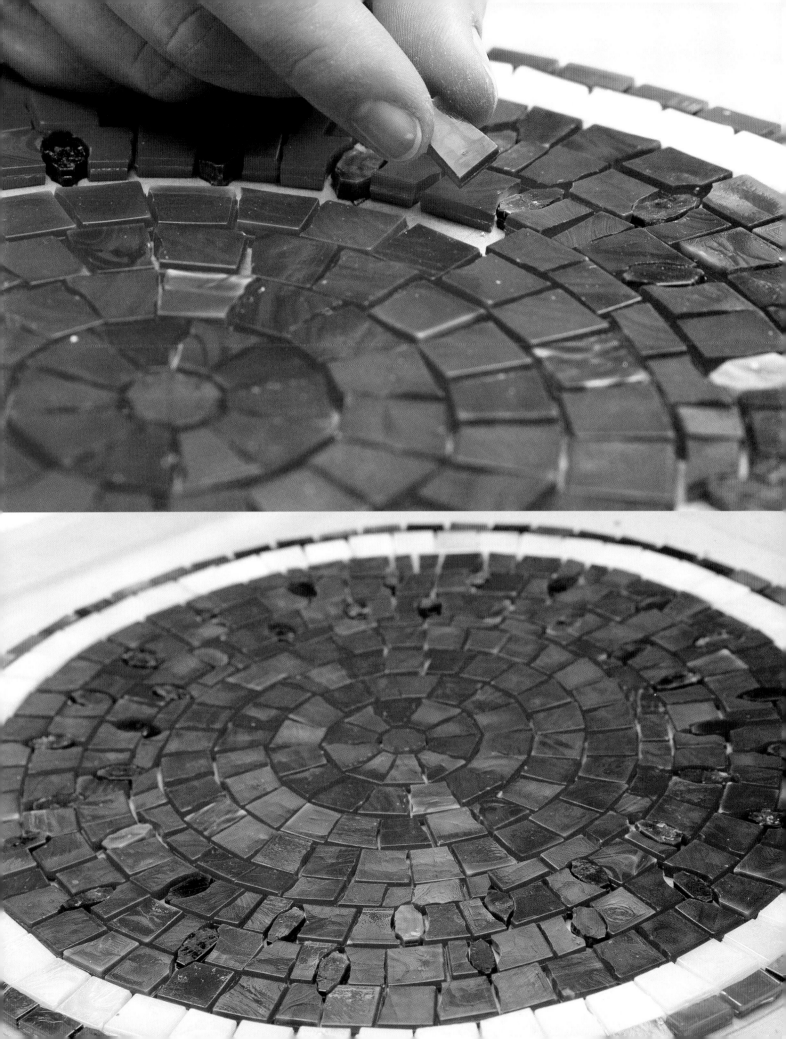

Working on glass

Translucent materials will add a new dimension to your mosaic palette. For items to be lit from inside, choose strong colours because the light will dilute the intensity. Use grout lines as an essential part of the design; they will add character when the piece is lit, like the leading in stained glass. With three-dimensional transparent objects beware of designs with different colours on opposite sides as they will be visible through each other. The Bloomsbury Tea Light (see page 48) is used here to show working 'glass on glass'.

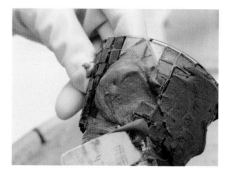

1 Draw the design in black felt tip on the inside of the glass – you can simply rub it out when you have finished. Alternatively you could just add guidelines with strips of sticky tape.

2 See page 22 for guidance on how to use silicone adhesive. Start with the three or four central focal patterns. Add the vertical lines on the sides and then fill in the remaining area with the background colour. With conical objects like these tea lights, use larger pieces at the top where the diameter is greater and smaller ones at the bottom where it is narrower.

3 Leave the project to set, then grout in the normal way.

Grouting

Anyone who has had the pleasure of mixing cement will have no trouble grouting. If your work is tight with small gaps between tesserae, you will need less grout; if there are big gaps, you will need more. As a rule of thumb, 150g (5oz) of dry grout should be enough to grout a piece around 30cm (12in) square, but always read and follow the manufacturer's instructions. The drying of grout is a chemical process and takes about 24 hours – placing the mosaic somewhere warm will not speed up the drying time. Clean the tools and mixing bowl immediately after use, scraping off excess grout with newspaper and putting it into a bin – never put it down a drain or it will soon become blocked.

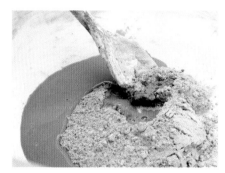

1 Pour the powdered grout into a mixing bowl and make a well in the centre. Gradually add water and mix thoroughly with a wooden spoon. The mixed grout should be around the consistency of toothpaste – if it is too stiff, it won't flow into the gaps, and if it is too wet it will wash out. The grout will go darker when water is added, but will dry the same shade as the dry powder.

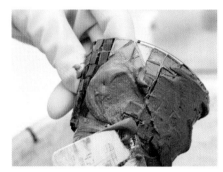

2 When you apply the grout, place a good dollop on the item and go over it with a grout spreader, smoothing it in all directions so that it is pushed thoroughly into the gaps.

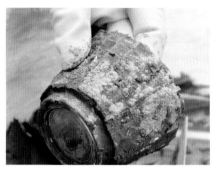

3 Get rid of the worst of the excess grout by scraping it off, then sprinkle some dry grout powder over the surface. Leave for about 10–20 minutes.

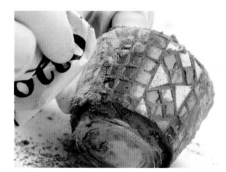

4 As it starts to dry, gently rub the excess grout off the surface with pieces of newspaper.

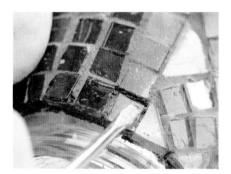

5 When grouting a direct mosaic, the surface will not be completely flat. This usually means that you will need to scrape away some of the grout to reveal hidden tesserae. Before the grout is dry, you can rub or scrape this excess off with a small tool like a screwdriver or a bradawl. Take some trouble at this stage; it is much harder to remove grout once it has fully set.

Take care

Always wear rubber gloves and a facemask when grouting, as grout is a chemical substance that can be irritating to skin and lungs. If you get some grout on your hands, rinse them with vinegar or lemon juice diluted with water. The acidity of the vinegar or lemon juice will compensate for the alkalinity in the cement and thus restore the natural pH balance of your skin.

Casting
a slab

Mosaic motifs can be cast into slabs, either as freestanding decorative pieces or to inset into a path or patio. You will need to decide how thick the slab should be – if it is to fit into an area of other paving you will need to match the thickness of the surrounding slabs. Here the Ravenna Star Paving Slab from page 84 is used to show the steps for making a slab.

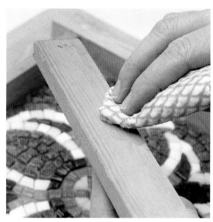

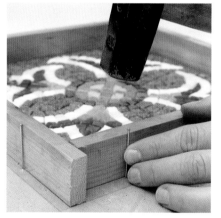

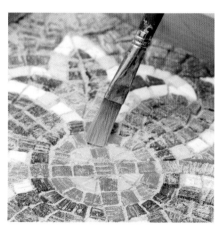

1 Make up the indirect mosaic using adhesive film as shown on page 26. When making the mould, choose a width of timber a little larger than the final depth of your slab. Cut four pieces, each the length of the mosaic, plus an extra 5cm (2in). The extra bit will protrude at each corner, which gives you something to hit with a hammer when removing the mould. Rub a little wax onto one surface of each piece, just on the section that will form the inside of the mould. This will act as a release agent, preventing the finished slab from adhering to the wood – it is a bit like greasing a cake tin so that the cake doesn't stick.

2 Place the pieces of wood around the motif to create a mould, leaving a gap all around of about 3mm (⅛in) between the side of the mould and the mosaic to protect the edge of the mosaic when cast in the final slab. Fix the sides in position with a couple of tacks hammered into the base board on each side of the outside edge of the mould. You can also seal the joins in the corners of the mould with PVA if you wish.

3 To prevent the cement from seeping through onto the final mosaic surface, sprinkle grout in the middle of the design, then brush it gently into the gaps between the tesserae.

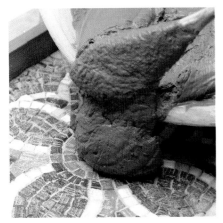

Put a large dollop of cement into the mould and press it down gently but firmly to smooth it out across the area. Work downwards, do not scrape or pull the trowel across the mosaic surface, as this may displace the mosaic tiles.

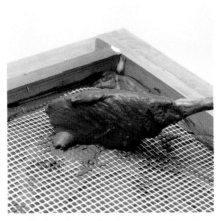

Cut a piece of nylon, or preferably metal mesh such as chicken wire, 1cm (⅜in) less all around than the size of the mosaic to reinforce the slab. Place the mesh in the mould, then add another layer of cement to cover it.

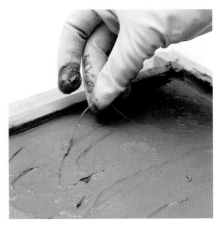

At this stage, if you want to hang your mosaic, you can wrap each end of a length of hanging wire around two small screws and press them into the cement about one third down from the top of the design. These will form a hanging loop when the slab is finished.

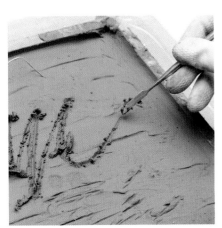

Sign and date the back of the slab, if you wish, and leave it to dry.

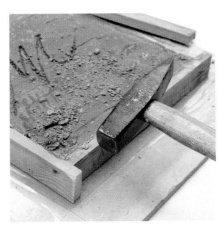

Remove the pins holding the mould in place, then firmly tap on the protruding ends on each side of the mould to knock them away from the cast mosaic slab.

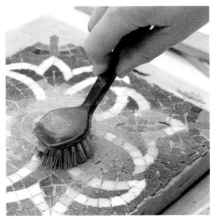

Turn the slab over and peel off the adhesive film. Brush away any loose dry grout, then grout across the whole area as usual.

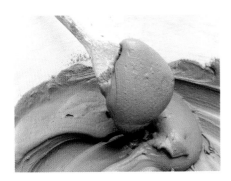

In the mix

Mix the cement in a bowl with a wooden spoon, following the manufacturer's instructions. Do not get the cement too wet or the final slab will warp – it should be a thick enough consistency to stay on the spoon when it is lifted clear of the bowl. Mix thoroughly, but work fast if you are using rapid-setting cement, as it will begin to set quite soon.

Using metal bases

Metal bases are strong and suitable for outdoor use. Setting a mosaic into a metal tray may seem to be a daunting process but it is really quite straightforward. To build up your confidence and familiarity with this technique, I recommend that you try setting a practice piece such as the Kilim Table on page 92.

 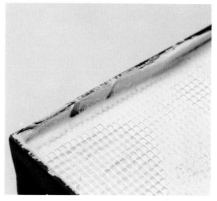

1 Make up the top of the table using indirect mosaic on adhesive film as shown on page 26. Use exterior-grade tile adhesive for fixing – the best choice is a flexible, slow-drying type. Adhesive is available in several colours, but white will give the tiles maximum luminosity – particularly if you have used Sicis Iridium or Water Glass. Mix the tile adhesive following the manufacturer's instructions.

2 Spread an even layer of adhesive that half-fills the tray. Cut a piece of mesh 1cm (⅜in) less all around than the size of the tray. This will both stabilize the mosaic panel and form a flat layer over the reinforcing rods, if there are any, in the bottom of the tray base. Place the mesh on top of the adhesive and press gently into position. Add more adhesive on top.

3 Spread the extra adhesive across evenly to a height the thickness of your mosaic beneath the top edge. Pay special attention to edges and corners and try to release any air bubbles that may be trapped in the adhesive.

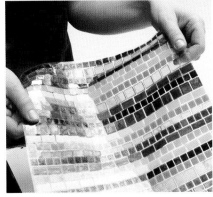

4 Carefully place the design motif into the tray, tile side down – so the plastic adhesive film is facing upwards. It may be easier to centre the design in the tray if you ask someone to help you lift it into position. Remember, it will be possible to adjust the mosaic slightly in the tile adhesive if it is not perfectly placed the first time.

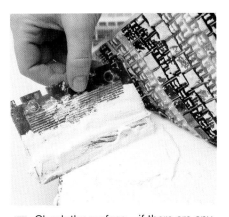

5 Check the surface – if there are any dips near the edges you can carefully peel the mosaic up again on its plastic film in the affected area and add a little more tile adhesive to fill the dip. However, if you feel that the tesserae will come off the plastic, it is better to leave well alone.

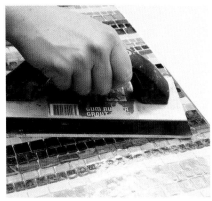

6 Now that the mosaic is well positioned, gently press it into the tile adhesive. Smooth a builder's float over the surface of the plastic film to flatten out any bumps. If any excess tile adhesive squeezes out from around the sides as you do this, simply wipe it off.

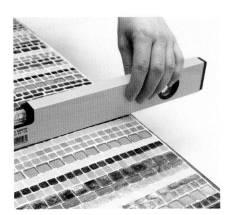

7 Pull a piece of wood across the top a couple of times in alternate directions to level the surface in line with the edges of the tray.

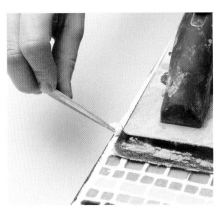

8 Keep flattening and scraping out excess tile adhesive until you are happy that the top is as smooth and flat as possible. The plastic film on the surface will delay the setting of the adhesive, so you have some time in which to work. Leave the table for around 12 hours to allow the adhesive to firm up.

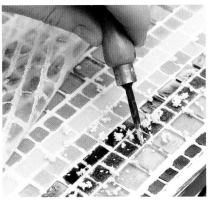

9 When the adhesive is firm but before it has fully set, carefully peel off the plastic film and gently scrape out any excess adhesive with a bradawl, being careful not to displace any tiles. Leave the table to dry thoroughly before grouting – the time needed for this varies according to the adhesive you have used, so check the manufacturer's instructions.

Fixings

When you have finished your mosaic you will want to display it. There are several hanging methods, depending on whether you want a permanent or temporary display. Remember that a large piece will be very heavy, so the fixing needs to be very secure.

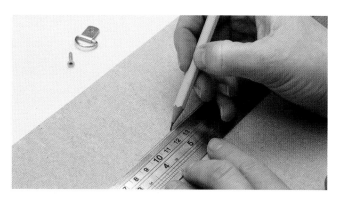

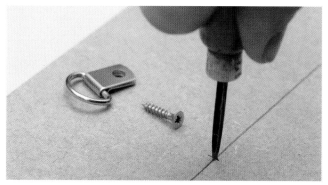

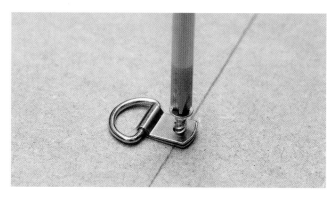

D-rings

This fixing is called a D-ring because the ring forms a letter D. The advantage of the D-ring is that it is hidden away on the back of the mosaic so you won't be able to see it. A single D-ring should be fixed a third of the way down from the top of the mosaic. Drill a small pilot hole first to make it easier to fit the screw. Use a small screw to fix it in place, but make sure it is no longer than the thickness of your base board. For larger pieces there are larger D-rings that need two screws. For mosaics up to 30cm (12in) square one small D-ring is absolutely fine, for pieces up to 45cm (18in) square one large D-ring is required. If your piece is any bigger you will need two of the large D-rings fixed 6.5cm (2½in) in from each side. String a nylon cord or picture wire between the two rings. If you want to hang your mosaic on a chain (as shown in Four Elements Wall Decoration on page 72) you can twist a length of wire through the D-rings and then through the links of the chain.

Magnets

Magnets are best for small, lightweight pieces, although you can use more than one. The best way to fix magnets is to glue them in position with a two-part epoxy resin. Make sure the back of the mosaic is clean and dust free. Magnetic fixings will only hold your piece onto metal with a high proportion of iron or steel content – it will not work on aluminium, bronze or brass.

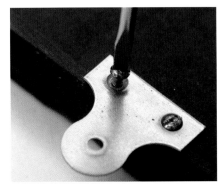

Mirror plates

The advantage of these type of hangers is that the mosaic will sit absolutely flush against the wall, and they are more secure than some of the other choices. If you are exhibiting your work In a gallery or some other public space, mirror plates are recommended, as the piece will be much more difficult to take down than a mosaic that is hung on a hook. The disadvantage of mirror plates is that you will have the rounded part of the plate sticking out on each side of the mosaic piece. If you wish, you can paint them to match the colour of the surrounding wall to disguise them. Put one mirror plate on each side of the piece on the reverse, slightly above the centre point, with the rounded part protruding over the edge. Screw the plates into position from the back, then turn the piece over, position it on the wall and screw through the rounded section into the wall. If you are using brass mirror plates, use brass screws to match.

Wedi board

Wedi board has no structural integrity to hold screws, so add a hanging cord before you start your mosaic. Make a hole right through the board 10cm (4in) down from the top and 15cm (6in) in from the side, then a second one around 2cm ($^7/_8$in) below it. Repeat on the other side of the board. Trim the top and bottom from a rawl plug to fit, and push the resulting 'tube' into each hole to line it. Thread a double piece of cord through the top hole, back through the bottom one, pull across and repeat on the other side. Knot the ends on the back to make a hanging cord on the back and two small lengths of cord on the front. Pull the cords on the front tight and glue into position, then mosaic over them.

Concealed fixings

An alternative way to hang something flat on a wall is to remove one tesserae from each corner about 5cm (2in) in from the edges and drill a clearance hole right through the back of the mosaic. Countersink the hole then use countersunk screws to fix the piece to the wall. Replace the missing tesserae and the fixings will be invisible. If you think that you will want to remove the mosaic at a later date, you can do a rubbing of each corner with a piece of paper and a pencil and mark which tesserae hides the screw. Although this last method is the most time consuming, it is the safest and most professional because the mosaic will be flush to the wall and you will have no fixings showing.

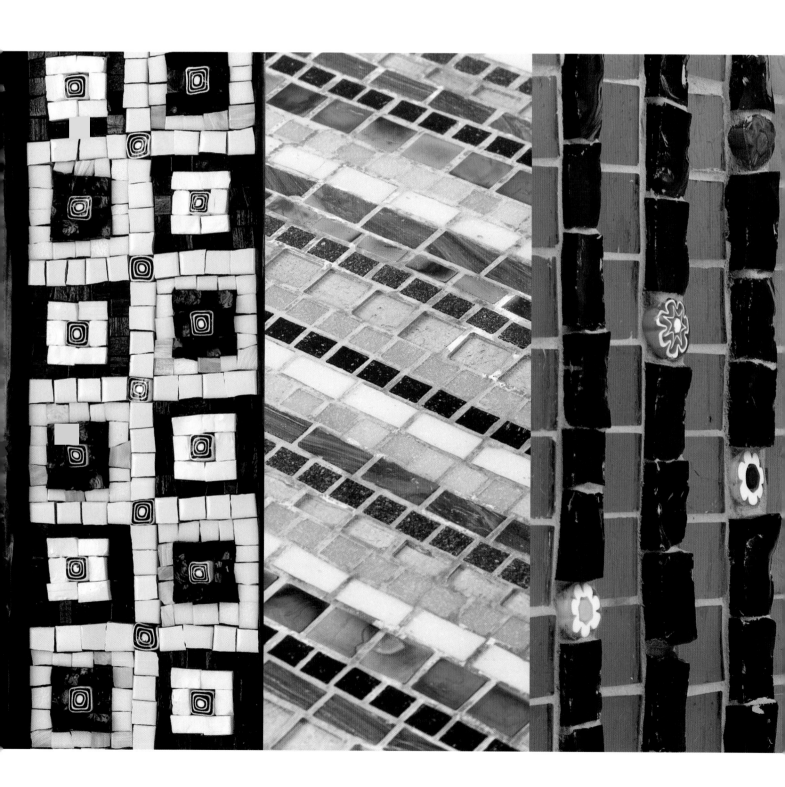

Projects

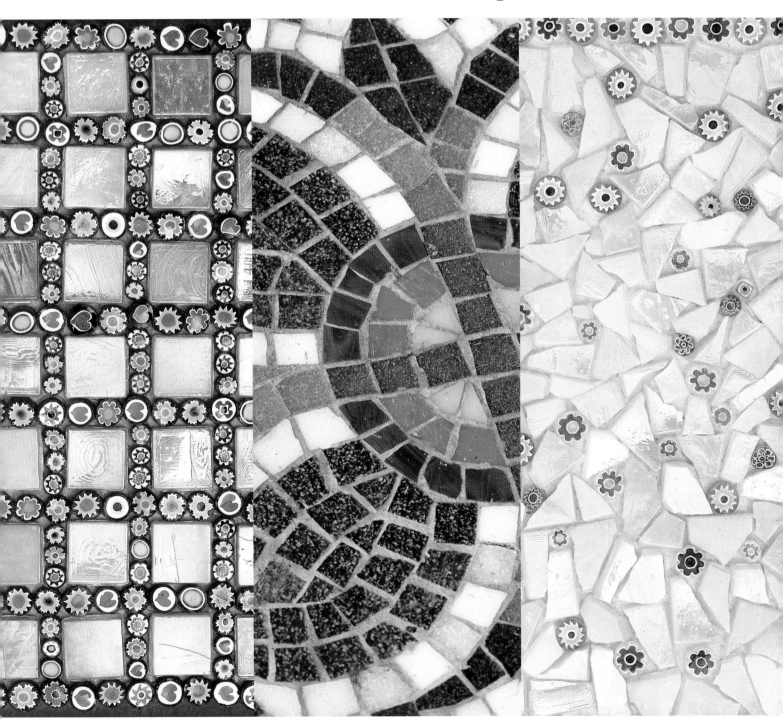

Gingham platter

This fresh summer platter is effective and very easy to make. You simply stick whole translucent tiles to a glazed dish using transparent silicone adhesive and then grout. A white or off-white dish will make the most of your wonderful luminous tiles. There is no cutting required, but the use of silicone glue and grout means that the finished dish is not dishwasher proof.

Materials list

26 x 26cm (10 x 10in) square glazed white or off-white ceramic platter

1 tube of silicone glue (50ml) – this will be enough for several dishes

49 Sicis Water Glass tiles in colour 1 (dark)

84 Sicis Water Glass tiles in colour 2 (medium)

36 Sicis Water Glass tiles in colour 3 (light/white)

300g (10oz) white or off-white grout (the same colour as the platter)

Techniques

Direct mosaic (page 22)

Grouting (page 31)

Difficulty rating

● ● ● ● ●

Time scale

1–2 hours

Measure the sides of the platter and mark the mid point of the gingham pattern high up on each side. Do not draw a line between the marks across the base, because you will be able to see it through the translucent tiles and will not be able to rub it out later. Start by making central horizontal and vertical lines to form a cross, thus establishing the middle of the dish. Dot one spot of silicone glue for each tile along these lines. Following the gingham pattern place the tiles, beginning and ending with a dark toned tile. Adjust the lines as required to

make sure they are straight and to even up the gaps. It is fine if it is not too perfect – you want your dish to look handmade. Work around the edge of the platter next, again beginning and ending with a dark tile. Finish each quarter of the platter keeping to the gingham pattern. If any excess glue squeezes up between tiles as you work, scrape it out gently with a small screwdriver or other pointed tool. Leave the platter to allow the silicone to set fully before grouting – this will take at least 12 hours.

DESIGNER AND MAKER:
ARENDSE PLESNER

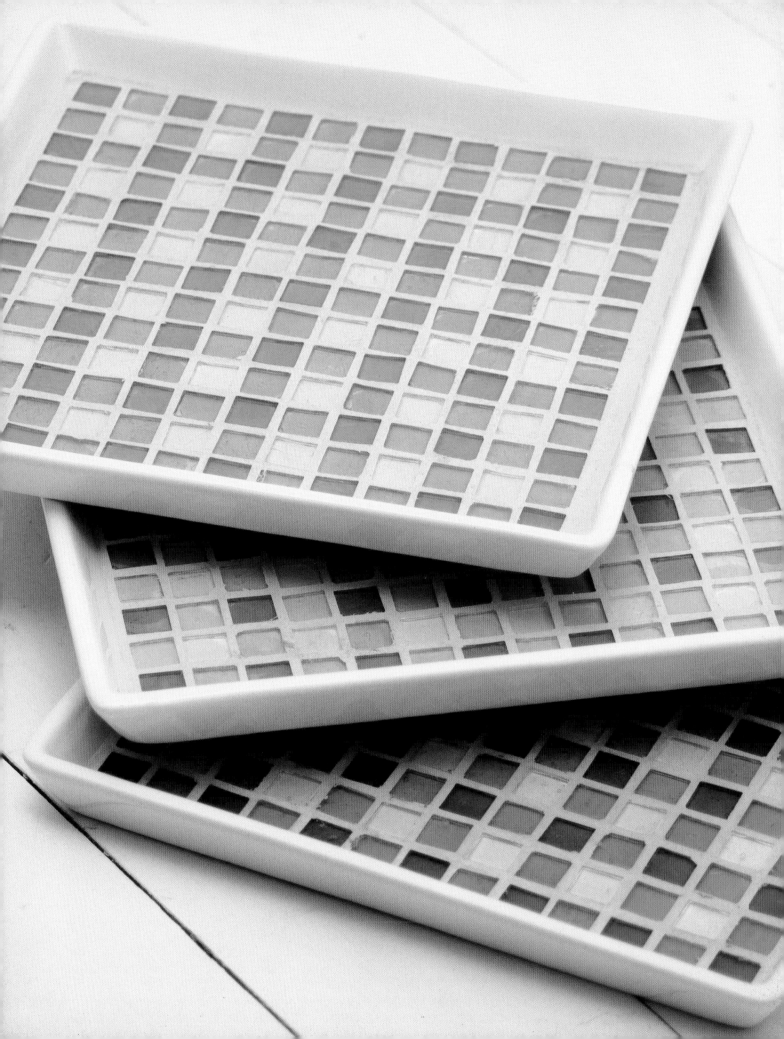

PROJECT 01

House number

What better way to inform your friends or visitors that here is the house of a creative person than by having a mosaic house number? This can be delicate and discreet, or you can go completely overboard and include your house's name. This house number is for indoors so it is made on MDF with PVA glue and it is not grouted. The edges are painted in a matching colour and mirror hangers attach it to the wall. Note that you may need more or less tesserae than given here, depending on the number you are making.

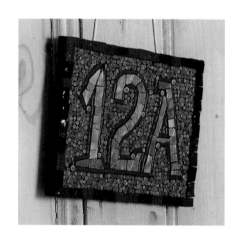

DESIGNER AND MAKER:
ARENDSE PLESNER

Materials list

15 x 20cm (6 x 8in) piece of
MDF or mesh
PVA glue

 50 gold smalti
for number

 450 small millefiori
in blue for outline

 750 small millefiori
in a selection of colours for
background

 12 larger millefiori
for the background

 43 smalti
in mixed blues for the border

2 mirror plates
2 matching screws

Techniques

Transferring the design (page 19)
Cutting (page 20)
Direct mosaic (page 22)
Mirror plates (page 37)

Difficulty rating

Time scale

1 day

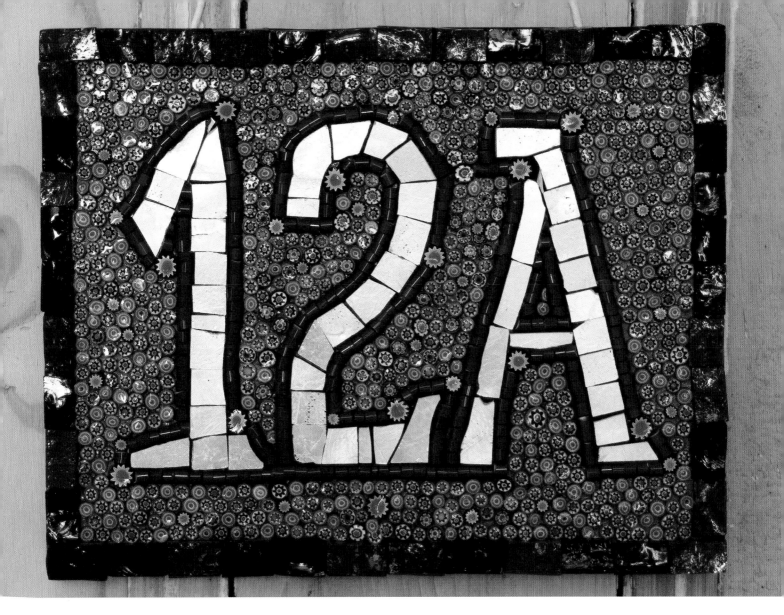

1 Decide whether your house number will be installed inside or outside and choose a suitable base and adhesive.

2 Enlarge your number to a suitable size to use as a template. Transfer the design onto the MDF or mesh base.

3 Run a bead of glue around the edge of the mosaic and stick down a row of smalti briquettes to create the border. Let the border set while you find or cut suitable pieces of gold leaf smalti to make up your number, then place them in position and stick them down.

4 With the small blue millefiori go around the outside of the gold numbers to create an *opus vermiculatum*, placing the millefiori on their sides. Allow this line to set and then fill in the background area with a random pattern of small millefiori with the odd larger millefiori here and there, always making sure that you keep the whole composition balanced.

5 Leave the mosaic to dry fully then add mirror hangers or install on the wall using your chosen method.

Back to front

If your number is going inside on a porch you can make a direct mosaic on a board and hang it up like a picture. If it is going outside it can be made on mesh and installed more permanently with tile adhesive, although if the finished mosaic is large you may need to provide support while the adhesive is setting. Obviously if you are doing letters and numbers by the indirect method it is essential to work mirror-image, so the final result is the right way round!

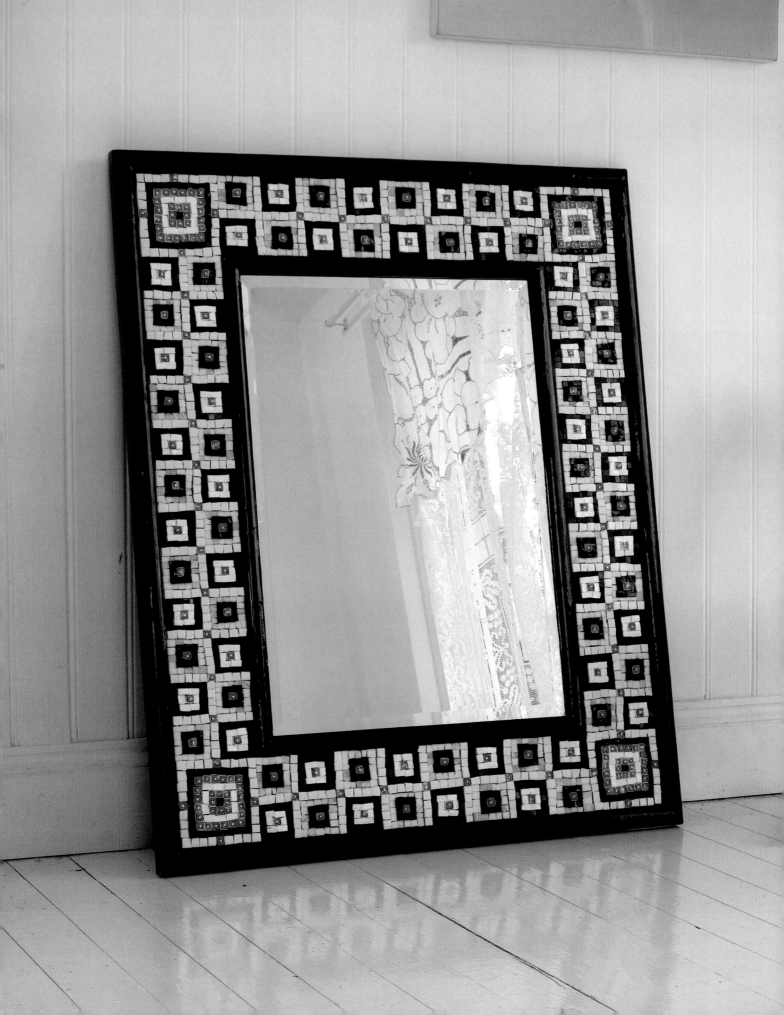

Gustav Klimt mirror

The inspiration for this mirror was the square, black-and-white millefiori – very unusual as millefiori is normally round and bright colours. Arendse created some Gustav Klimt-like patterns on this black mirror frame, so the square millefiori echoes its shape. Make a similar frame by mounting a mirror with a wood border on a base board 15cm (6in) wider all around, then add a matching border along the outside edge.

Materials list

85 x 105cm (42 x 34in) mirror frame with a double border leaving a 12cm (4³⁄₄in) wide channel for the mosaic design

 250 millefiori
in black and white for detailing

 300 smalti
in black for squares and centres

 250 smalti
in white for squares and centres

 150 matte-glazed ceramic tiles
for corner squares, outline and grid

 225 black vitreous glass
for squares and centres

 225 white vitreous glass
for squares and centres

PVA glue

Two large D-rings

Techniques

Transferring the design (page 19)
Direct mosaic (page 22)
D-rings (page 36)

Difficulty rating

Time scale

 2–3 days

DESIGNER AND MAKER:
MARTIN CHEEK AND ARENDSE PLESNER

PROJECT 02

1 When you are ready to start mosaicing, cut up a pool of all the tiles you need and spread out the smalti and millefiori. Some tesserae are larger and some are smaller and to make your pattern fit the frame you will need to use larger pieces of one kind of material and smaller pieces of the other. Choose the least expensive material or the material that cuts most easily for the lines that you will need to trim for the final fit.

2 Start with the corners, as it is very important that they fit in the frame. Cut a piece of black smalti for the centre and go around it with a row of millefiori. Choose the millefiori for a good fit as the mirror is not grouted so you want the gaps between the tesserae to be as small as possible. Now go around again with a row of white smalti briquettes. Again, choose from the pool for a good fit, or trim if you have to.

3 The next row is a full row of millefiori. Then comes a row of black smalti and the last round to finish off the corner square is a row of glazed ceramic tiles with four centrally placed pieces of millefiori.

4 Trim to fit, even though the matte-glazed ceramic tiles used here will wear your nippers and your wrists. Repeat the design for all four corners.

5 Work out the grid to run down each side and lay the continuous white lines in glazed ceramic tiles. These need to be relatively straight to give the design some structure. As you lay the lines, place a millefiori where they join. Place one millefiori in the centre of each square you have created and go around it with one row of white or black smalti. Allow everything to dry.

6 Fill in all the gaps with the appropriate black or white vitreous glass, cut to size. The smalti, millefiori, ceramic tiles and vitreous glass are all different in size and thickness, which gives a wonderful texture in the otherwise quite static black and white design. To add D-rings, follow instructions on page 36.

Graphic design

You may have to spend some time playing with the frame that you are going to use, laying out your chosen tiles to make everything fit within the dimensions of the mirror. Graph paper is very useful while making patterns and getting them to fit, but playing with the different materials is also essential.

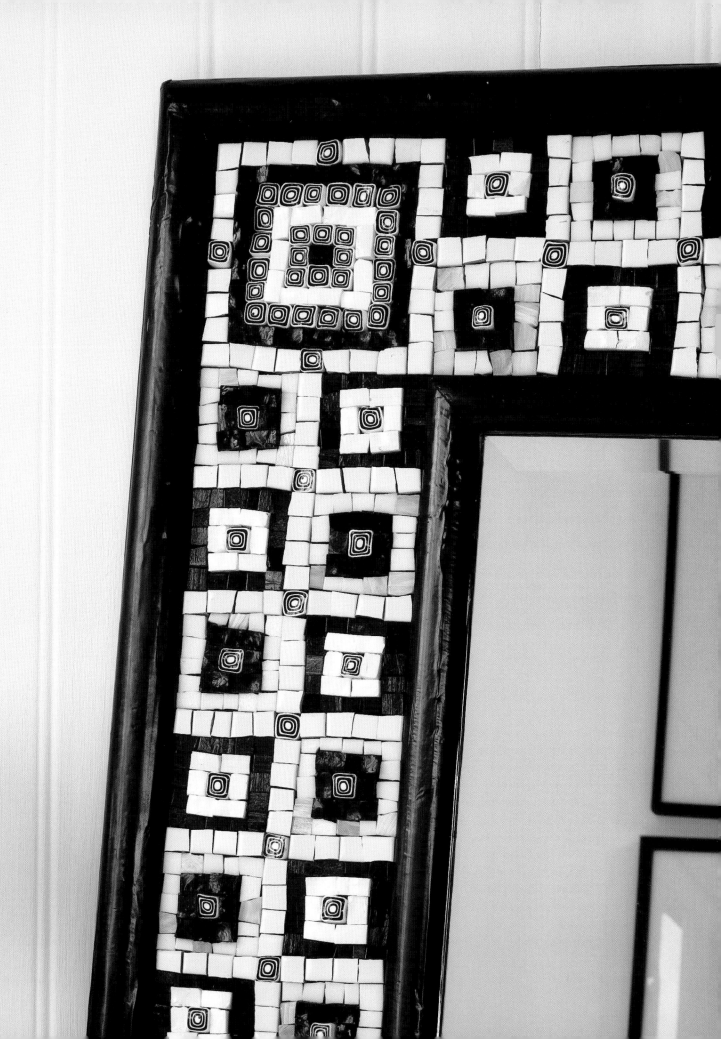

PROJECT 03

Bloomsbury tea light

These tea lights are inspired by a Bloomsbury wallpaper design that I saw one night on television, in the background of a scene in the film *Carrington*. I loved the colours and made two different plaques in vitreous glass. The design was adapted by Arendse for these attractive and useful coloured tea lights. The lines of grout look like the leading in stained glass when the candle is alight. This project looks easy because it is small, but working small makes it a fiddly process – small pieces are needed because the surface you will be working on is curved and you do not want sharp corners or edges sticking out, which could be dangerous.

DESIGNER AND MAKER:
MARTIN CHEEK AND
ARENDSE PLESNER

Materials list

Glass tea light holder

1 tube of silicone glue (50ml)

10 Sicis Water Glass tiles in colour 1 (deep bright) for diamond

5 Sicis Water Glass tiles in colour 2 (contrasting) for diamond

15 Sicis Water Glass tiles in colour 3 (pale) for diamond

15 Sicis Water Glass tiles in colour 4 for vertical columns

15 Sicis Water Glass tiles in colour 5 for background

1 tea light candle

300g (10½oz) grey grout

Techniques

Transferring the design (page 19)
Cutting (page 20)
Direct mosaic (page 22)
Working on glass (page 30)
Grouting (page 31)

Difficulty rating

● ● ○ ○ ○

Time scale

 2–4 hours

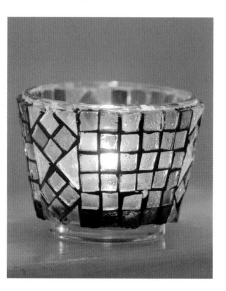

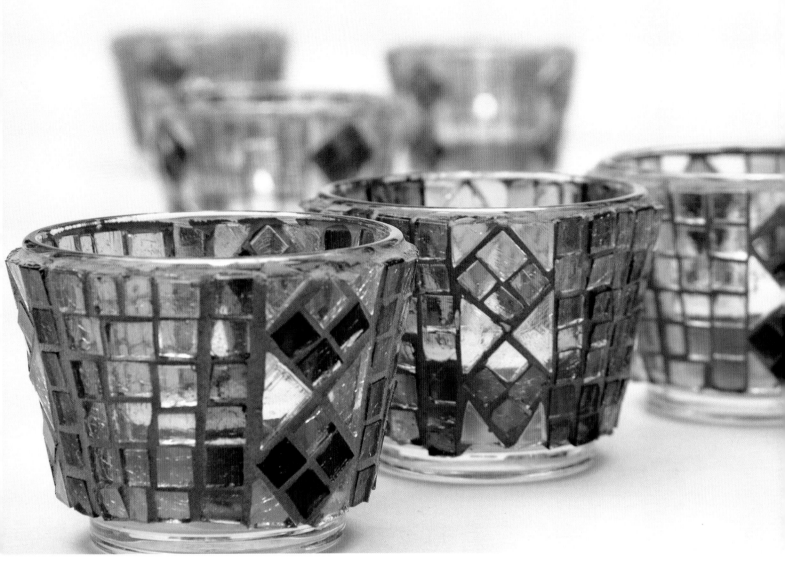

1 Enlarge the template (below right) to the size of your tea light holder. Tape the template on the outside of the glass, and draw the design in black felt tip on the inside of the tea light – you can just rub it out when you have finished. Remove the template.

2 Start to lay out the main vertical lines of the design by placing small dots of silicone glue and placing the colour 4 tiles. With flared objects like the tea light use larger pieces at the top where the diameter is greater, smaller at the bottom where it is narrower.

3 When you have finished the main lines, make the centre diamonds in colours 1 and 2.

4 Finally fill in the background areas with colour 3. Leave the tea light overnight to dry thoroughly then grout.

Going round in circles

Remember also that the surface you are working on is curved, so lay out pieces with long sides running down the curve not across it.

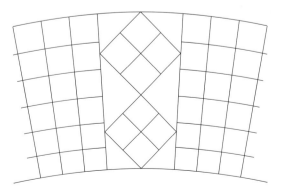

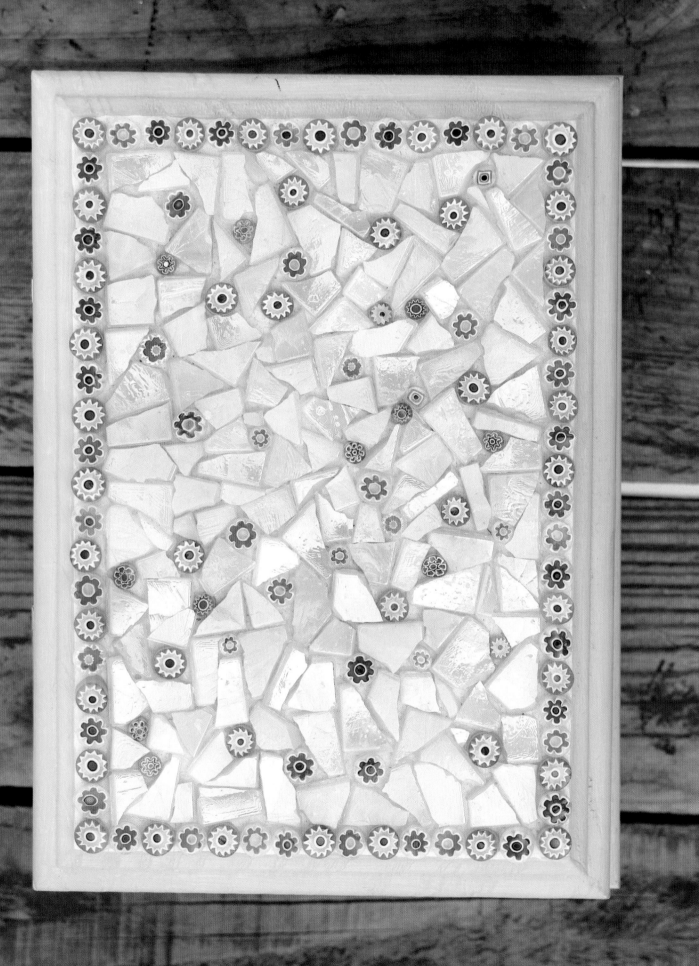

minute mosaic

Jewellery boxes

Pretty wooden boxes in bright colours with mosaic tops are an attractive way to store jewellery or other little bits and pieces. These luscious boxes are very easy so make and require either no cutting or only very simple cutting, depending on the pattern. Millefiori around the edge is pretty but is also a safety feature to help avoid having cut or spiky pieces on the edge.

Materials list

10 x 15cm (4 x 6in) wooden box with a lid

PVA glue

Wood stain or coloured varnish

For the green box:

 70 millefiori
in green for edging

 45 millefiori
in assorted designs for highlights

 30 Sicis Iridium
in green for background

For the blue box:

 35 Sicis Iridium
in blue for background

 240 millefiori
in assorted designs for gridlines

Techniques

Direct mosaic (page 22)
Cutting (page 20)

Difficulty rating

 ● ● ● ● ●

Time scale

 1–2 hours

Colour the box green with paint or wood stain and let it dry completely. Using the small green-toned millefiori, place beads of glue and go right around the edge of the lid with a line of millefiori. Allow the glue to set. For a Gaudi-like feel cut the Sicis Iridium tiles into crazy paving pieces and begin sticking them on with PVA. Start with the bigger pieces on the outside and work your way towards the middle. Fill in the odd corner with a millefiori every so often, so that they are scattered over the top of the box in a balanced way. You can leave the mosaic ungrouted, which I like to do, or can grout if you prefer or for safety reasons. For the blue box, work out the grid design based on the size of the tiles. Stick the tiles down first, then fill in the lines of millefiori, using the photograph as a guide.

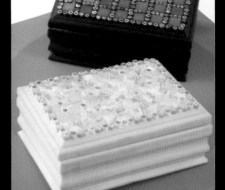

DESIGNER AND MAKER:
ARENDSE PLESNER

Pendant lamp

This delightful pendant lamp really shows off the lovely crackle effect in the Sicis Water Glass. Choose warm colours for a warm light and make sure you use a bulb that is designed to be seen uncovered, so there is no glare when the lamp is switched on. You may have to try different bulbs when your lamp is in position to make sure you get the best light. If you made a different design in brighter colours, you could achieve the effect of a real Tiffany lampshade at a fraction of the cost and the labour!

DESIGNER AND MAKER:
ARENDSE PLESNER

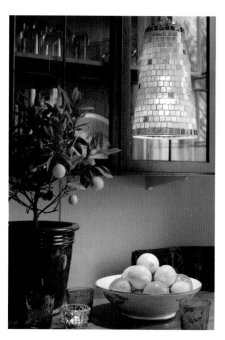

Materials list

Glass lampshade 30cm (12in) high
1 tube of silicone glue (50ml)

100 Sicis Water Glass tiles in red for top and bottom rings

10 Sicis Water Glass tiles in amber for peppering background

10 Sicis Water Glass tiles in ocher for peppering background

500 Sicis Water Glass tiles in yellow for the background

300g (10½oz) grey grout

Techniques

Transferring the design (page 19)
Cutting (page 20)
Direct mosaic (page 22)
Working on glass (page 30)
Grouting (page 31)

Difficulty rating

● ● ○ ○ ○

Time scale

 1 day

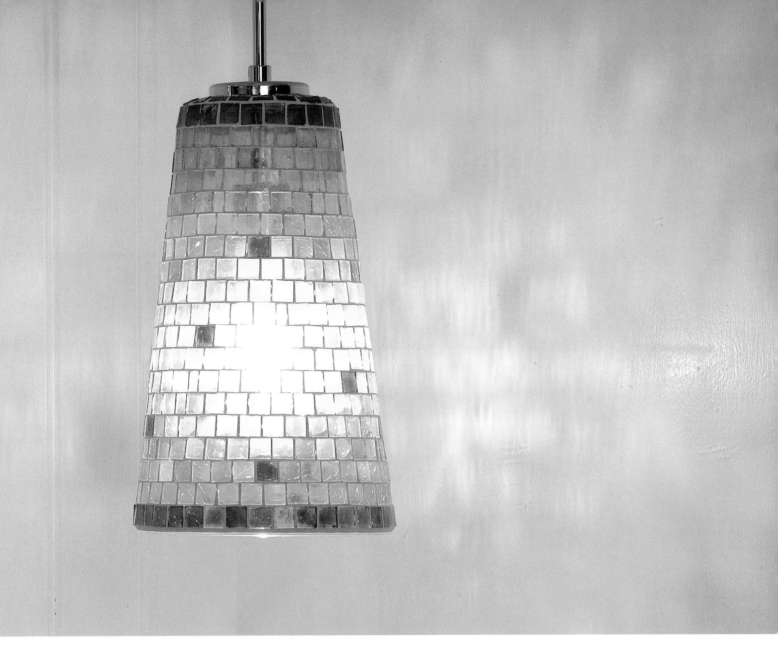

1 Start from the bottom of the lampshade and work your way upwards. The first ring is red, which works as a contrast to the basic yellow/amber colours of the main design and adds to the warmth of the light.

2 Dot the silicone around the bottom of the lampshade in a line and stick on a row of whole uncut red tiles. Tweak and adjust the positioning until your first row is neat, trimming the last piece to fit if you have to. When you place the tiles, make sure that there is glue under the entire tile, but not so much that it comes up in the gaps.

3 Keep working towards the top of the lampshade in rows, offsetting the gaps so you get a pattern like a brick wall. Drop in the odd contrasting colour in as you go – try and make sure that there is an overall balance of the colours in the finished lamp.

4 When you have one full row to go before the lampshade curves in towards the fitting, make another line of red to match that at the bottom. Fill in the curve towards the fitting with two rows of tiles cut in half, to achieve the line of the curve – if there is only room for one row here, then just do one row.

5 Let the silicone set overnight and grout the lampshade the next day.

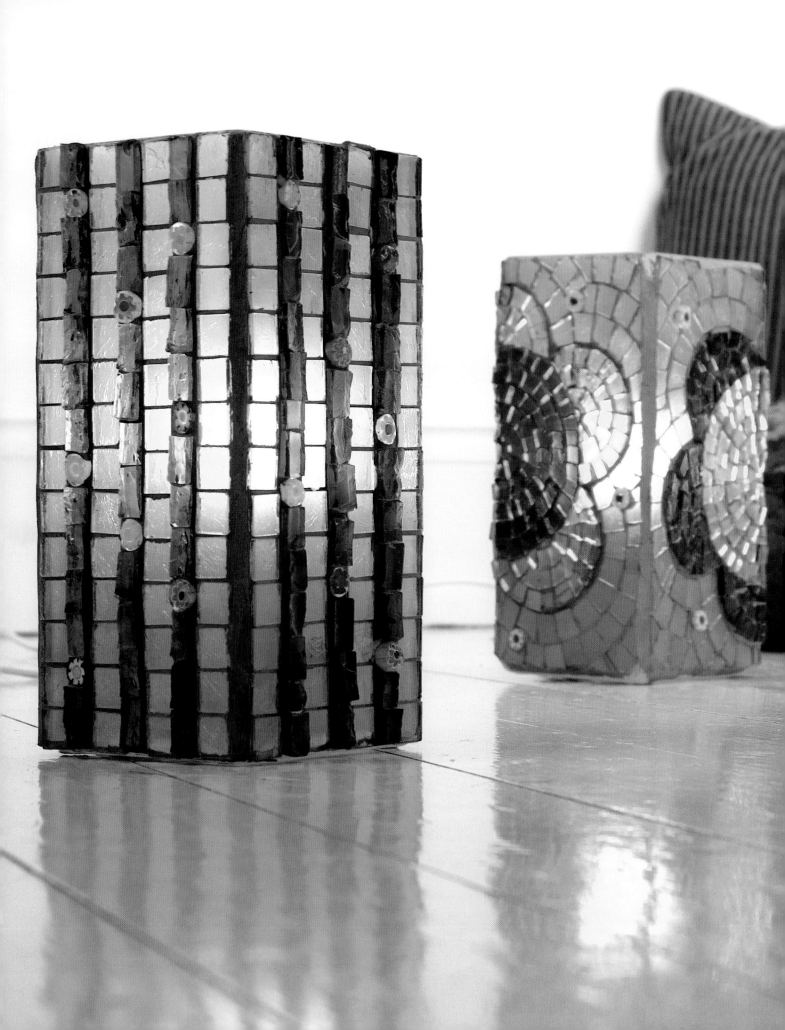

Square flower lamp

In this project the translucence of stained glass is combined with the technique of mosaic to make attractive 'stained glass' lamps, without having to worry about the lead involved in working with traditional stained glass. This bold flower lamp is inspired by the simple stylized shapes of designs from the 1950s. Choose strong colours for your lamp as they will brighten up a lot when it is lit. You can mix and match any translucent glass you can find to make the design. The alternative design shown left in the photograph is simply alternate stripes in smalti and Water Glass with millefiori details. Use a low-wattage frosted bulb.

Materials list

1 square glass lamp base
1 tube of silicone glue (50ml)
250 translucent smalti briquettes in colour 1 for flower
250 translucent smalti briquettes in colour 2 for flower
220 Sicis Water Glass in colour 3 for background
10 translucent millefiori 10mm (³⁄₈in) diameter
300g (10½oz) grey grout

Techniques

Transferring the design (page 19)
Cutting (page 20)
Direct mosaic (page 22)
Working on glass (page 30)
Grouting (page 31)

Difficulty rating

Time scale

2–4 hours

DESIGNER AND MAKER:
ARENDSE PLESNER

PROJECT 05

1 Enlarge the template (below right) to 19cm (7½in) in diameter, then tape it to the inside of the square lamp base across one of the side angles and near the bottom.

2 Start work on the back of the base, where there is access for the electric cord. Cut a little pool of translucent smalti in half, making the cut at an angle so you can achieve the curves of the flower.

3 Place the lamp flat on its side and start on the outer line of the centre of the flower, using colour 1 translucent smalti briquettes with the rippled side up. Make this line strong and neat as it defines that area of colour. Fill in the centre in concentric circles working inwards. Go quite close to the edge of the lamp base, but never beyond as this would leave sharp edges on the finished lamp.

4 Change to colour 2 smalti and mosaic the petals. Again start with the outer line to define the outline of the flower. Turn the lamp over to the next side and mosaic the other half of the flower in the same way. Let everything set before you continue or you may disturb what you have just finished.

5 Move the template to the other half of the lamp, turning it 180 degrees for added interest and to balance the design, and placing it near the top. Now mosaic the second flower in opposite colours to the first one: the centre with colour 2 and the petals with colour 1.

6 Fill in the background with translucent tiles in colour 3, following the curves of the flower. Pepper the background with some millefiori, but not right next to the flower itself – keep the *opus vermiculatum* clean! Again allow the first two sides to set before you begin to work on the last two.

7 When you have finished, leave the lamp until the following day to give the silicone time to set thoroughly before you grout your lamp. Since the millefiori and the smalti is thicker than the Water Glass, the grouting will take some extra patience and care.

Stripe off

To make the striped version you'll need 112 Sicis Water Glass in each of yellow and pale green, 70 translucent smalti briquettes in each of pale green and red, and 32 translucent millefiori.

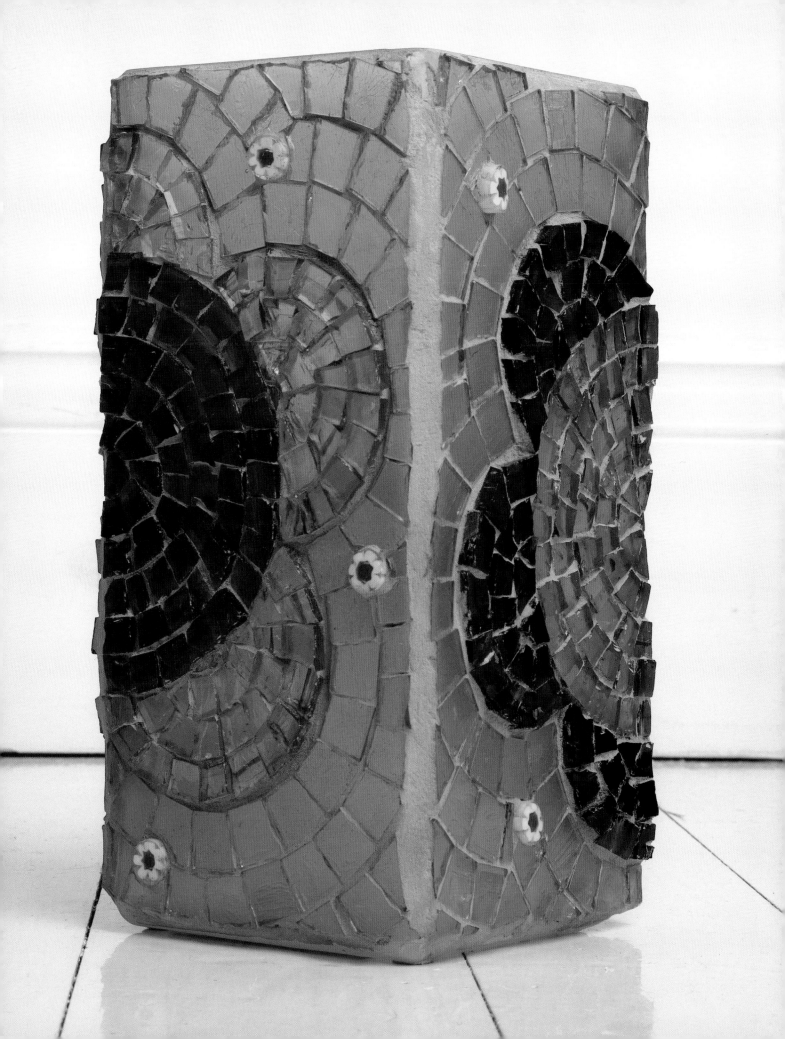

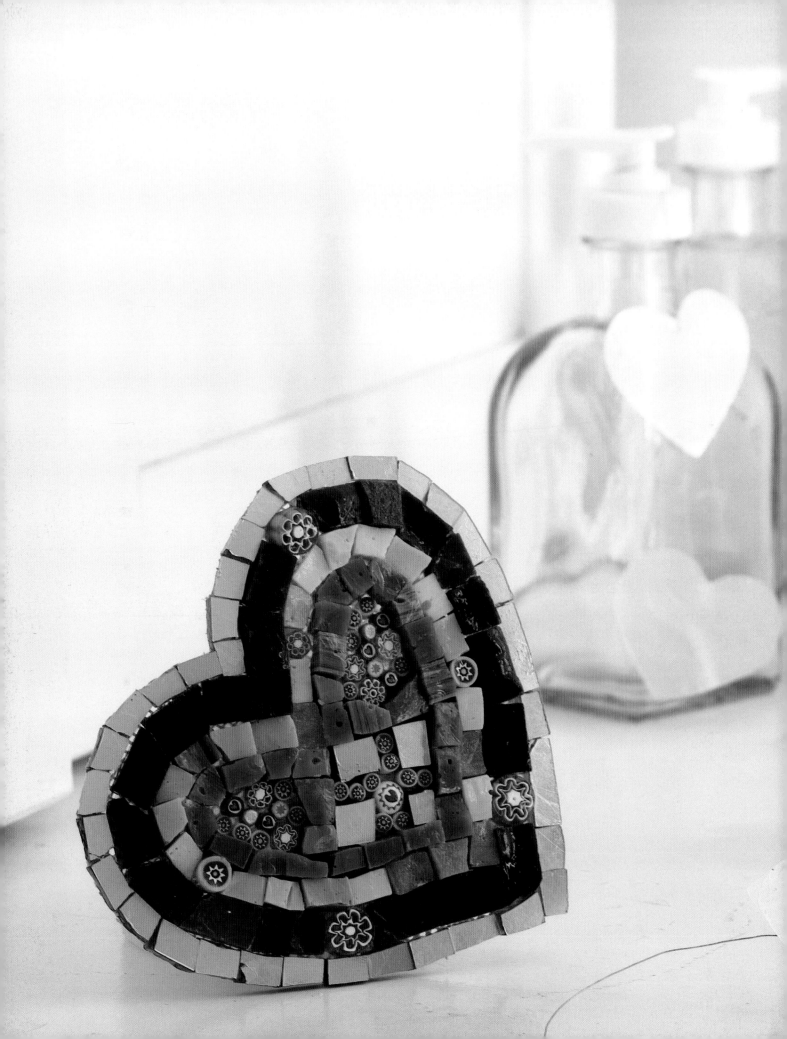

minute mosaic

Heart ornament

You can easily make beautiful motifs in mosaic, and using mesh enables you to make any size or shape you want. Fridge ornaments are always very popular, and to make your motif into one all you have to do is stick an appropriate number of magnets on the back. Here Arendse has made a heart inspired by a piece of Viking jewellery.

Materials list

Small piece of mesh

 32 smalti
for background

 76 gold leaf smalti
for centre and edging

 66 millefiori
for highlights

PVA adhesive

2 small magnets

Epoxy resin adhesive

Techniques

Transferring the design
(page 19)
Cutting (page 20)
Working on mesh (page 24)

Difficulty rating

● ● ● ● ●

Time scale

 2–4 hours

Prepare the design for working on mesh as described on page 24. When you work on mesh, the finished size does not have to be precise so you can work from the inside out, allowing the size of the tesserae to dictate the finished dimensions. Also, this project is not grouted as this dulls the colour. Using PVA adhesive, start in the centre by placing four pieces of gold leaf smalti with an appropriate number of millefiori around them. Cut each of the smalti briquettes into three tesserae, then create the first heart shape around the central decoration. Make the lines

of tesserae neat and well defined. Go around the heart as many times as you wish dropping in the odd piece of matching millefiori so that the overall effect is balanced. For the outline of the heart, cut gold leaf smalti into 10 x 4mm (³⁄₈ x ³⁄₁₆in) tesserae and place them all round the edge of your motif, trying to keep a neat outer line. Let the PVA dry over night, peel the mosaic off the plastic-wrapped baseboard, flip it and leave to dry again. When the adhesive has fully set, cut out the shape and fix the magnets on the back with epoxy resin adhesive.

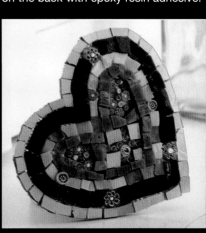

DESIGNER AND MAKER:
ARENDSE PLESNER

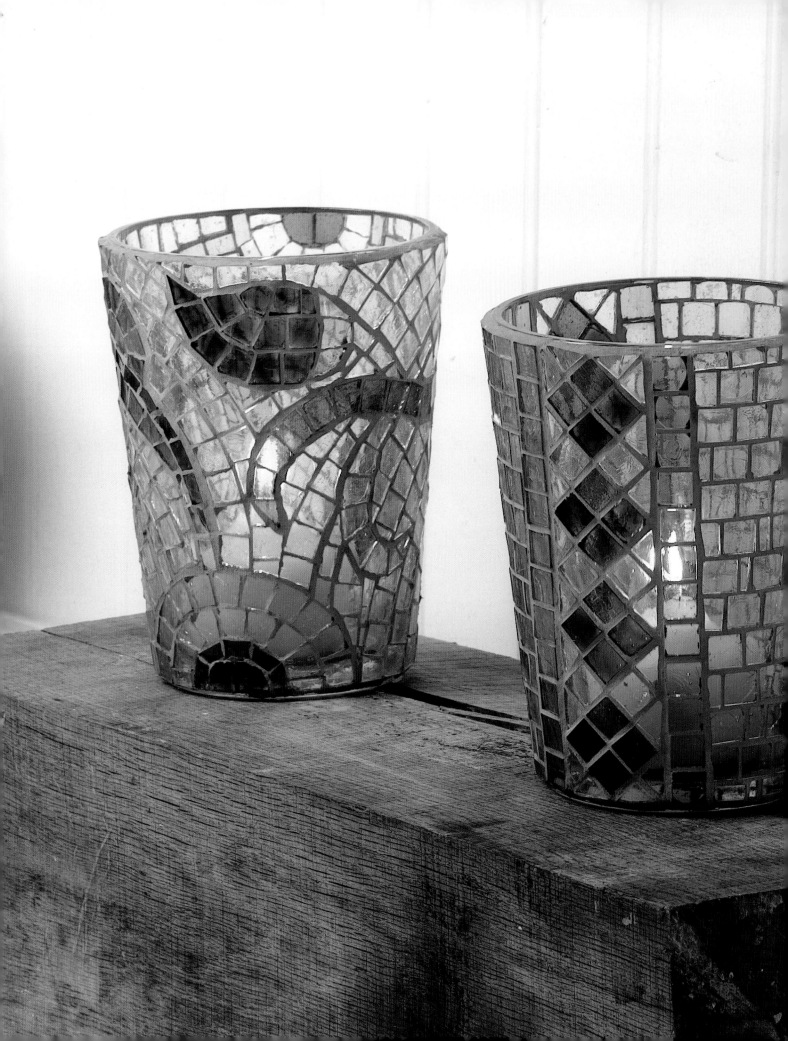

Storm light
Iznik tulips

The design of the lovely storm light on the left was inspired by the 2005 exhibition 'The Turks' at the Royal Academy in London – the classic tulip design from an Iznik tile was stylized for mosaic. The same colours are used in the Bloomsbury design on the right, which is still very effective, but is much easier to make as it only requires basic cutting.

Materials list

Glass storm light
1 tube of silicone glue (50ml)
300g (10½oz) grey grout

 36 Sicis Water Glass in colour 1 (dark green) for leaves and rosettes

 54 Sicis Water Glass in colour 2 (dark red) for tulips and rosettes

 72 Sicis Water Glass in colour 3 (purple) for leaves and rosettes

 90 Sicis Water Glass in colour 4 (turquoise) for stems, leaves and rosettes

 270 Sicis Water Glass in colour 5 (translucent) for background

Techniques

Transferring the design (page 19)
Cutting (page 20)
Direct mosaic (page 22)
Working on glass (page 30)
Grouting (page 31)

Difficulty rating

Time scale

 2–3 days

DESIGNER AND MAKER:
ARENDSE PLESNER

PROJECT 06

1 Enlarge the template (below) to fit the storm light and tape it to the outside of the glass base. With a felt pen, draw the design on the inside of the glass base. Because of the thick base you will not be able to draw all the way to the bottom so you will have to reconstruct the lines here as you work. Remove the template from the outside.

2 Start by mosaicing the half rosette that emerges from the bottom. Follow the colour numbers marked up on the template below for colour placement. Use whole tiles as basic units and trim them to fit as you work around the bends.

3 Now make the rosette on the opposite side emerging from the top. Make the red tulips with purple bases, and then mosaic the purple leaves. Next comes the big dark green and red leaf ending left out of the bottom rosette, then the turquoise leaf coming out of that leaf. End this line by joining up to the top rosette. Make sure that the basic line of these leaves and stems flows neatly from the bottom rosette to the top rosette.

4 Now mosaic the purple half rosette above the leaves you have just finished. The stem starting from the bottom left of the bottom rosette is next. Use trimmed half tiles and swing it in a circular movement all the way through the green and red leaf, through a purple leaf, through the big tulip, ending on the bottom about 5cm (2in) from the bottom rosette on the other side.

5 Continue by starting the turquoise line from the top rosette using half tiles. Set in about six pieces and then mosaic the dark green leaf swinging under the smaller upper tulip. Finish the turquoise circular line after you have finished the turquoise leaf emerging from the stem.

6 Fill in with turquoise stems to join up any loose leaves, tulips or stems.

7 The motif is finished, so now begin the background. The lines of the background are laid in *opus musivum*, and the shape they should flow in is indicated on the template by dotted lines. The background is very much a part of a mosaic, so how the lines are laid can make the difference as to whether the whole mosaic flows and comes to life.

8 When the background is complete, leave the storm light until the next day so that the silicone has properly cured before you grout.

9 To make the Bloomsbury design you will need 132 turquoise, 72 blue, 48 clear, 36 red and 12 green Sicis Water Glass tiles. See the photographs for tile layout.

Match side A to side A and B to B on each half of the template to achieve a continuous pattern. The colour numbers marked on the template are listed against each colour in the materials list.

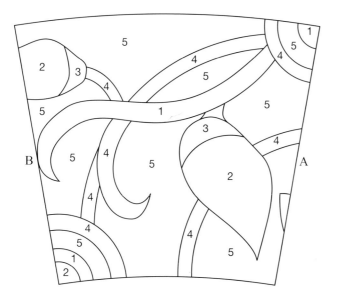

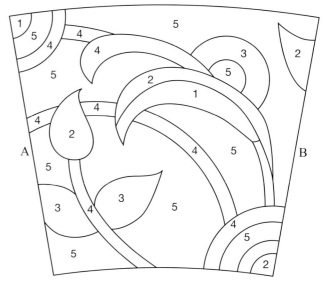

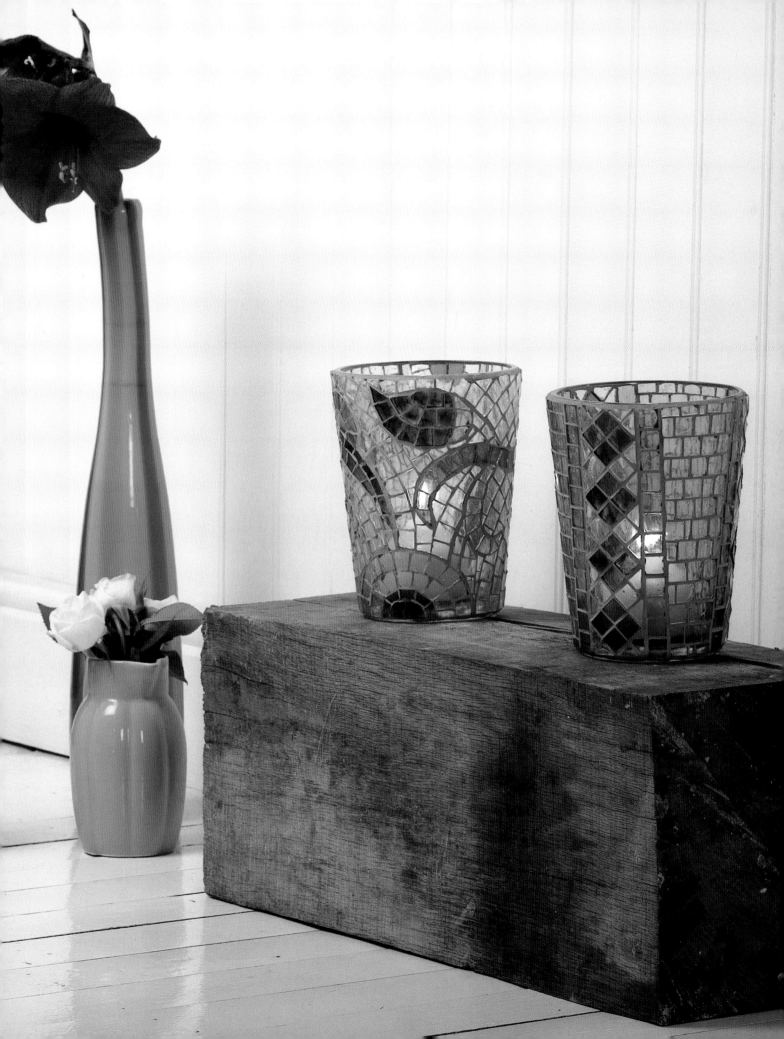

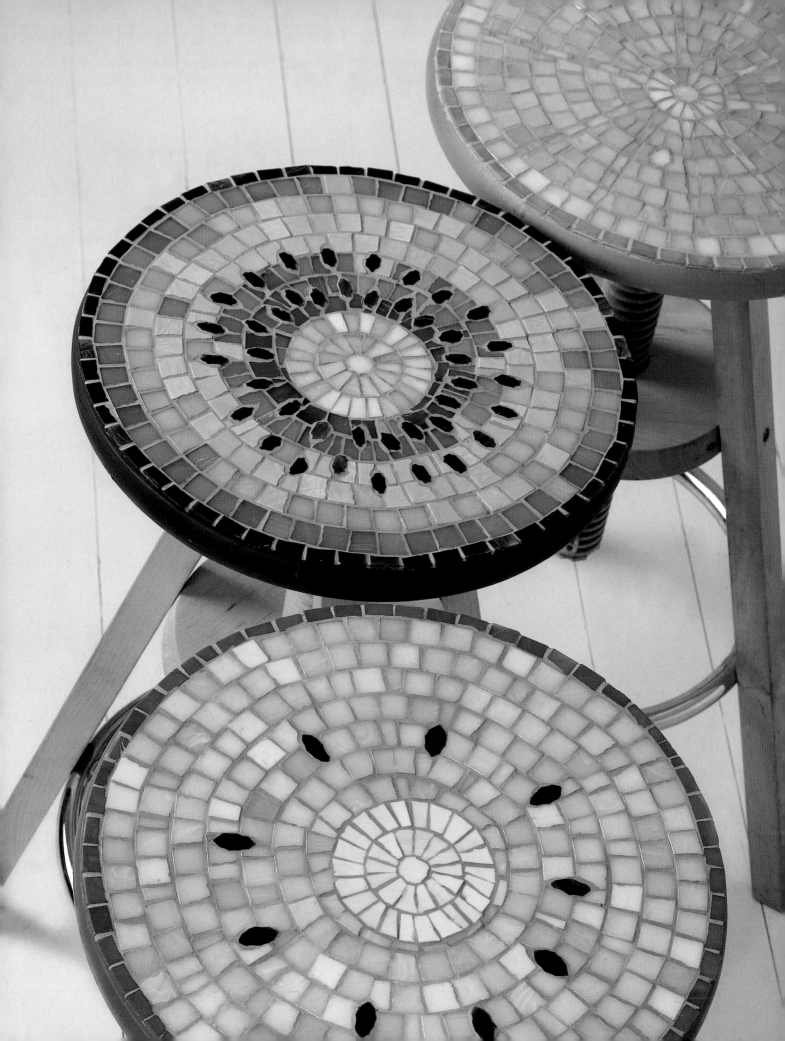

Fruit stools

The inspiration for these stools was the Sicis Iridium tiles, as I thought they looked really luscious and fruity. I chose to do four different fruits – watermelon, apple, orange, and kiwi – because although they are completely different colours, they work together because they are all fruit. The instructions here are for the watermelon (see page 26 for detailed images), but the others are made in the same way. What you are trying to achieve is an organic feel, rather than something geometric. The centre of the orange is offset, and the segments vary in size to give a lively, natural look. The orange is the most tricky as you need to show the pith.

Materials list

1 round wooden stool
Adhesive film
- **60 Sicis Iridium** in colour dark green for rind
- **220 Sicis Smalto** in colour red for flesh
- **60 Sicis Iridium** in colour cream for inner rim
- **40 Sicis Smalto** in colour dark brown for seeds

PVA adhesive
150g (5¼oz) grey grout

Techniques

Transferring the design (page 19)
Cutting (page 20)
Indirect mosaic (page 26)
Grouting (page 31)

Difficulty rating

● ● ●

Time scale

◐ 1 day

DESIGNER AND MAKER:
MARTIN CHEEK

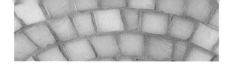

PROJECT 07

1 For the watermelon, enlarge the template (below bottom right) to the size of the top of your stool and stick it down onto a base board to work on. Centre the adhesive film over the motif and tape it down.

2 Start by working around the outside edge in green Sicis Iridium to make the rind. You need to set the tiles 2–3mm (¼in) in from the edge line so the final mosaic will not overhang the top of the stool. Make sure you place the smooth machine-finished edge of each tile along the outside edge as the cut edge may be sharp.

3 Establish the centre of the stool and place a circle cut from red Sicis Smalto. Work outwards for two more rows in cream to create the central core.

4 Cut seeds from the dark brown tesserae by nibbling off the corners and place in two rows, making them a little bit irregular in shape and positioning them unevenly for a more natural effect.

5 Start filling in the design with red, working in towards the centre in rows and cutting the tesserae as required to make the concentric circles and to fit around the seeds. If you are making the orange, the centre is offset so the final row should be narrow on one side and wide on the other.

6 When the mosaic is finished leave it for 24 hours or more to let the tesserae sink into the adhesive film. Follow the steps on page 28 to add the mosaic to the top of your stool.

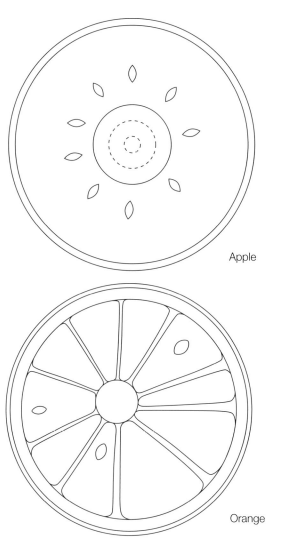

Apple

Orange

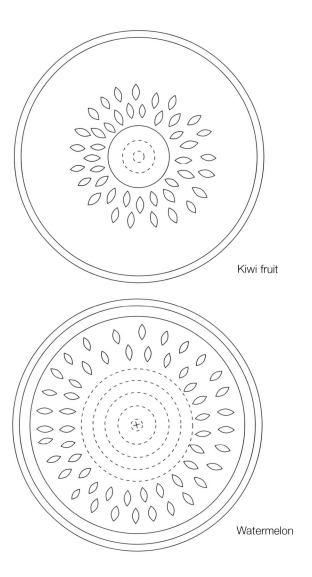

Kiwi fruit

Watermelon

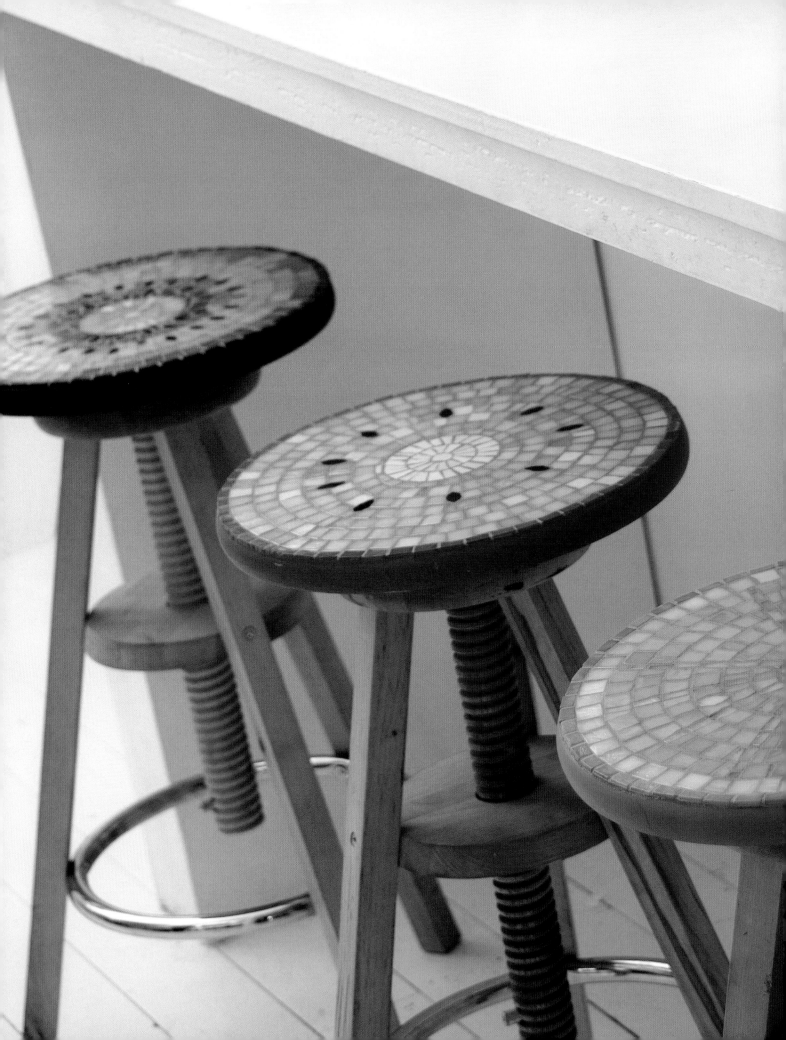

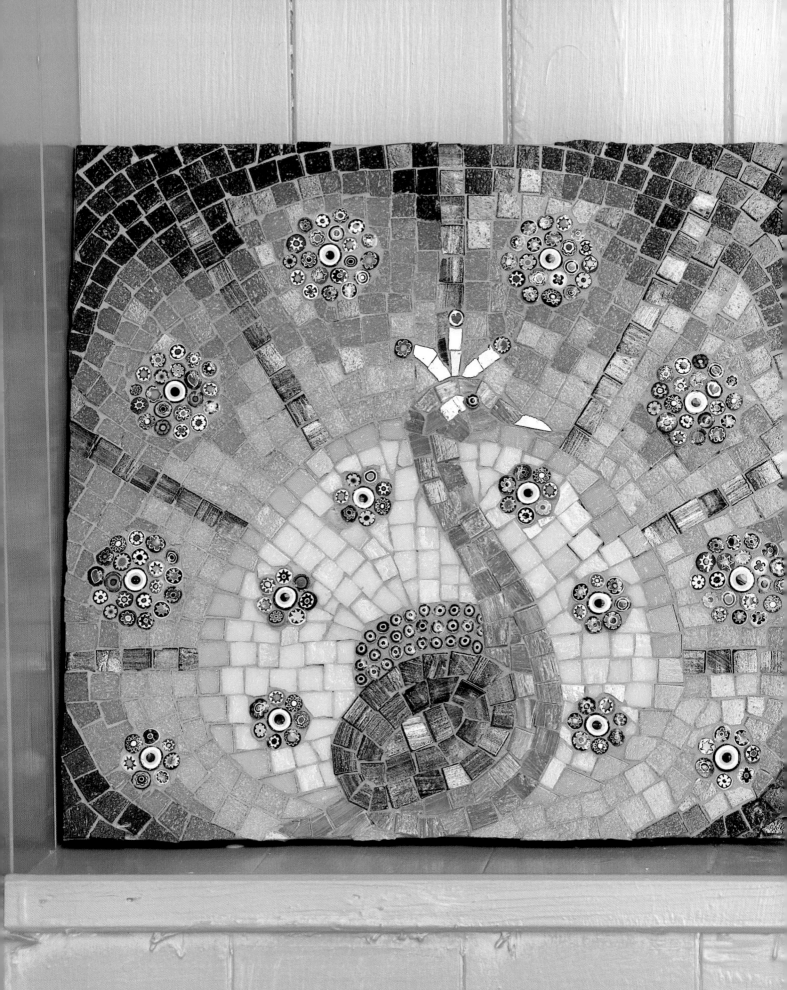

Peacock
display plaque

This majestic peacock, fanning his tail feathers in a brilliant display of colour, makes a wonderful piece of artwork. Peacocks lend themselves to this type of work, with their strong, flowing lines, flamboyant colouring and the intricate detail of the eyes on the fan.

Materials list

30 x 28cm (12 x 11in) piece of MDF board

16 vitreous glass in dark grey for outer background

10 vitreous glass in ultramarine for inner background

10 vitreous glass in dark blue for outer feathers

16 vitreous glass in dark turquoise for outer feathers

16 vitreous glass in mid turquoise for outer feathers

17 vitreous glass in green vein for radiating lines

11 vitreous glass in blue vein for the wing

17 vitreous glass in turquoise vein for the body and neck

36 vitreous glass in lime green for feathers

12 vitreous glass in tangerine for the fan line

25 vitreous glass in yellow for inner feathers

15 gold smalti for the crown and beak

30 turquoise millefiori for the back

14 blue millefiori for the eye and feather eye centres

85g (3oz) of millefiori mix for the feather eyes

PVA adhesive

150g (5¼oz) grey grout

Techniques

Transferring the design (page 19)
Cutting (page 20)
Direct mosaic (page 22)
Grouting (page 31)

Difficulty rating

● ● ●

Time scale

1–2 days

DESIGNER AND MAKER:
MARTIN CHEEK

PROJECT 08

1 Enlarge the template below to 30 x 28cm (12 x 11in) and transfer it to your base board. Sort out the millefiori into different sizes and colours, so you can find the ones you need quickly as you work.

2 Start by placing a large blue millefiori bead in the centre of each of the eight eyes on the outer ring of the peacock's tail, and one in the centre of each of the six eyes on the inner tail ring.

3 Add a row of seven medium-size mixed millefiori beads around each large bead, then add a second row of thirteen beads to the outer row only.

4 Make the crown from gold leaf smalti, then place the peacock's blue millefiori eye in position – move it around until you get a position you like. Make the head and neck in turquoise vein, then the wing in dark blue vein.

5 Fill in the millefiori at the base of the tail, then create the tangerine fan line. Fill in the yellow area, radiating the lines of tesserae outwards to give a sense of tail feathers fanning.

6 Work the radiating lines, then fill in the tail working from the base of the tail outwards.

7 Finally fill in the background in the top and bottom corners. Leave the plaque to dry overnight, then grout.

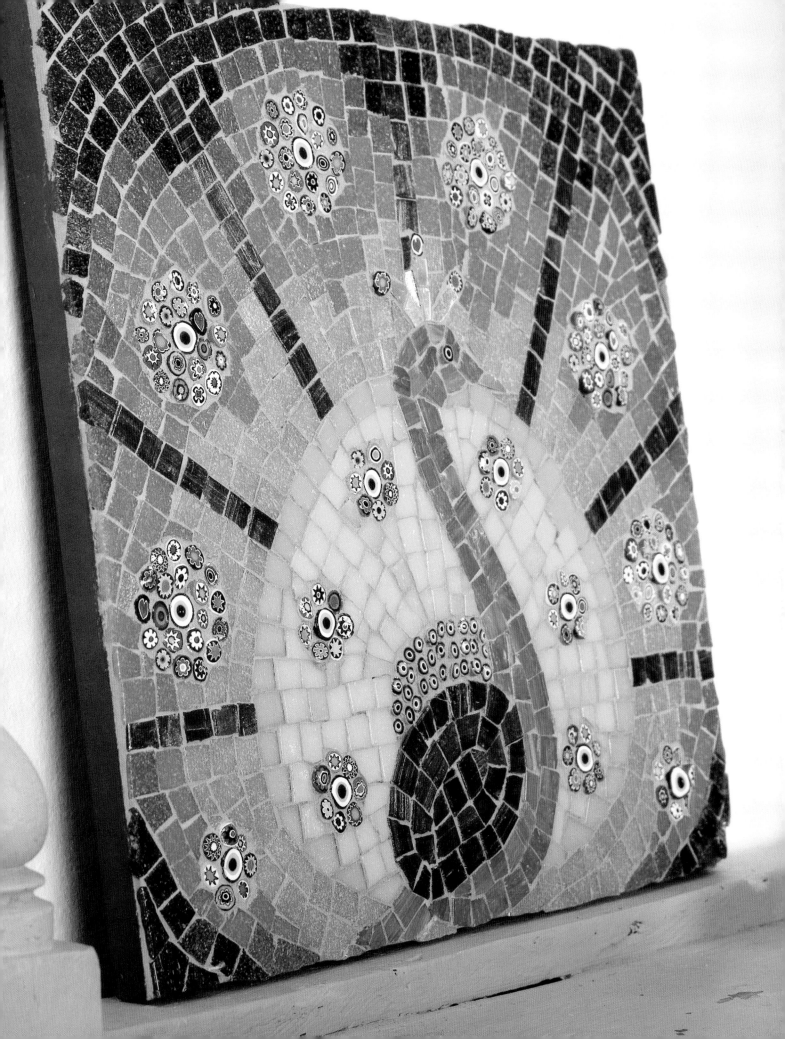

Four elements wall decoration

These pieces have a great impact because of their unusual shape – and if they had been square there would have been far more work needed to fill in all that background! They were made for an exhibition with the theme 'The Four Elements' and were inspired by jewellery pendants and ancient brooches. These designs are difficult to reproduce exactly as shown here because they require quite a good stock of roti, millefiori and gold leaf smalti, so they are really meant as an inspiration – fill the shapes in your own creative personal way.

Techniques
Transferring the design (page 19)
Cutting (page 20)
Direct mosaic (page 22)
D-rings (page 36)

Difficulty rating
● ● ●

Time scale
 3–4 days

DESIGNER AND MAKER:
ARENDSE PLESNER

PROJECT 09

Materials list

38 x 33cm (15 x 13in) piece of mesh or
MDF board for each motif

PVA glue

100 gold leaf smalti

for sun

4 orange gold leaf smalti

for sun

8 violet gold leaf smalti

for sun

250g (9oz) mixed bag of pinks
and orange smalti roti

for sun

75 silver gold leaf smalti

for dove

300g (10½oz) mixed bag of
smalti roti in assorted pastels

for dove

90 bronze gold leaf smalti

for horse

90 millefiori

for horse

400g (14oz) mixed bag of
smalti roti in light brown,
chestnut and beige

for horse

50 turquoise gold leaf smalti

for fish

250g (9oz) mixed bag of
smalti roti in blue, turquoise
and sea green

for fish

14 large millefiori flowers

for fish

2 millefiori for
dove and fish eyes

4 large D-rings

210cm (84in) length of metal chain

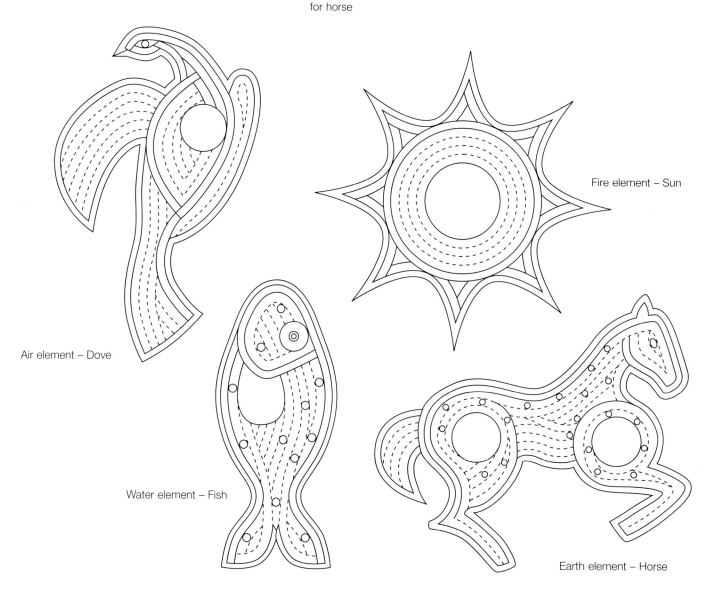

Air element – Dove

Fire element – Sun

Water element – Fish

Earth element – Horse

1 Blow up the templates to a suitable size, the originals are about 30–35cm (12–14in) high. Remember that working small is more fiddly and time-consuming than working larger. You can either work on mesh first, or cut the wood shapes and stick the mosaic tesserae straight onto the surface.

Fire element – the sun

2 Start by sorting out shades of pink from the roti box and cut up a pool of 10 x 4mm (³⁄₈ x ³⁄₁₆in) gold leaf smalti. Mosaic the outline in gold leaf smalti in a neat line around the edge of the shape. Make the first outer circle in smalti roti so that it touches all the dips of the gold leaf smalti, leaving eight triangular spaces behind. Go around again in another shade of pink. The next row is a row of gold leaf smalti and then there are two more rounds of pink roti. Fill in the middle with odd spiky shapes of pink and orange roti, dropping in four oblong pieces of orange gold leaf smalti. Fill in the triangles with one row of roti and trim violet gold leaf smalti to fit into the last gaps.

Air element – the dove

3 Sort out lots of whites and pastel colours and cut up a pool of 10 x 4mm (³⁄₈ x ³⁄₁₆in) silver gold leaf smalti. Trim two silver pieces for the beak, then go around the outline of the bird with silver. If you work on mesh, wait until you have filled in the body of the wings before you do the underlining of the left wing and the whole right wing. This way you may be spared some nasty precision cutting that is bound to make the lines of the roti look a little messy. Let the work dry. Using the white and pastel shades of roti, mosaic the key line going all the way from the beak to the tip of the tail. Start lighter and end darker to suggest that the light is coming from the top. Add a millefiori eye, trimming it for a less staring look. Put a pink piece in for the rose cheek. Gradually build up the design letting the *opus* describe the form of the bird, but leaving a circle in the chest. To get the three-dimensional effect here, choose some very long odd and spiky bits from the smalti roti and stick them in standing upright.

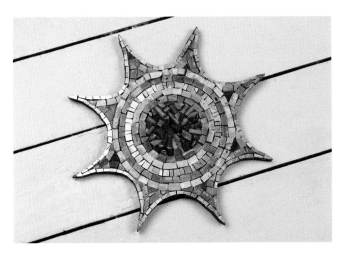

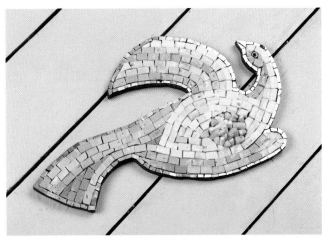

PROJECT 09

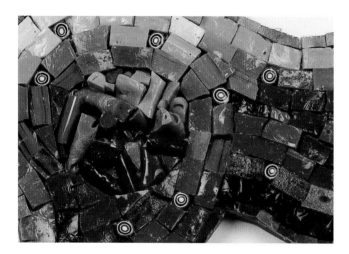

4 Earth element – the horse

For the horse you need brown millefiori and 10 x 4mm (⅜ x ³⁄₁₆in) bronze gold leaf smalti. Using the bronze, mosaic the outline of the horse. If you are using mesh, leave the line under the tail, the inside of the back leg and the underside and front of the front leg until these areas are filled with roti, to avoid difficult gaps. With roti, mosaic the key line from the forehead to the ground on the back leg. Shade the horse light on top, dark on the bottom. The next line goes from forehead to leg again. Drop in the pieces of millefiori as you work. Finish the lower back leg. Make a circular line from the middle of the back leg around to define the thigh; make another line leaving a circle for the three-dimensional effect. Mosaic the front leg, from the underside around in a circle to the front to define the chest. Repeat, leaving a circle for the three-dimensional effect. Choose some odd-shaped bits and stick them at angles in the two circles. Finish the front leg. Following the key line of the animal, finish the body, head and tail and any bronze outlining.

5 Water element – the fish

Blues, soft purples, turquoises, large millefiori flowers and turquoise gold leaf smalti are used here. Mosaic the outline of the fish with 10 x 4mm (⅜ x ³⁄₁₆in) pieces of turquoise gold leaf smalti. If you are working on mesh, leave the area where the body turns into the tail until you have mosaiced the body. Mosaic the key line, starting from the tip of the right side of the tail, going around the head and ending in the jaw to define the face. Place the millefiori eye and go around it with a row of soft purple roti. Build up the body of the fish, following its form. Leave a circle in the fin area for the three-dimensional effect and fill with odd-shaped bits at the end. Drop in some millefiori, shade the colours darker towards the tail; finish off the outline.

6

When the shapes are complete, leave them to dry. If you are working on mesh, cut the shapes out. To hang as shown opposite, add a D-ring to the reverse, twist a piece of wire through it and attach the pieces onto the length of chain.

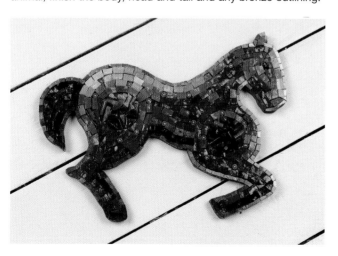

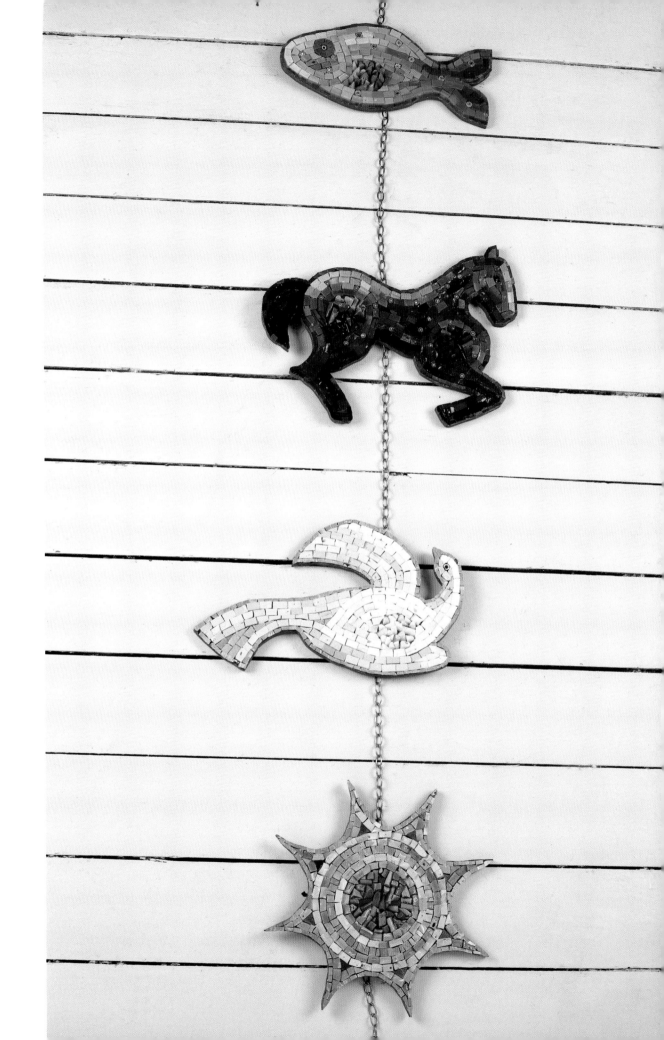

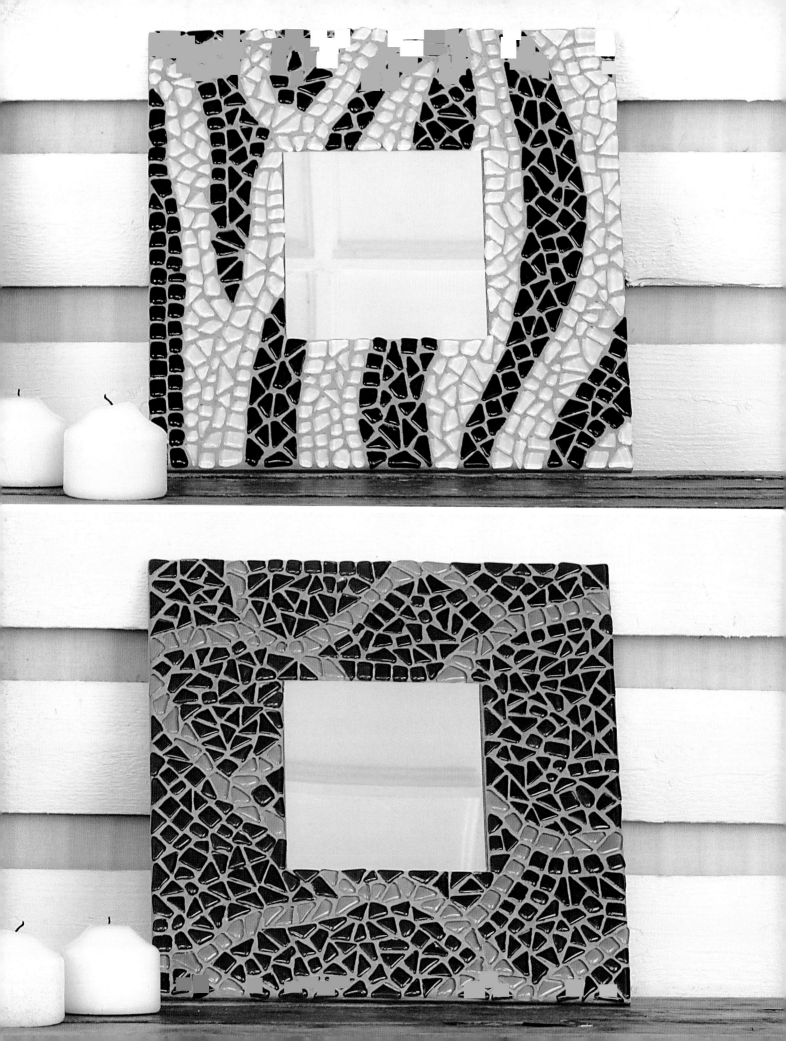

minute mosaic

Giraffe mirror

The inspiration for this evocative animal mirror came from the material itself. The organic shapes and the colour of the glass pebbles looked like the patterns on a giraffe. It was easy to picture how this mirror could be one of a series, so Arendse also made a zebra mirror. Any animal that has a strong coat pattern can be used as the basis for these designs.

Materials list

35cm (13¾in) square wooden frame with a 10cm (4in) square mirror in the center

For the Giraffe mirror:

 400 mosaic pebbles in brown

 110 mosaic pebbles in caramel for the lines

PVA glue
300g (10½oz) grey grout
Masking tape
1 small D-ring

Techniques

Transferring the design (page 19)
Direct mosaic (page 22)
Grouting (page 31)
D-rings (page 36)

Difficulty rating

Time scale

 2–4 hours

Adapt your own images of animal skin into a template. A useful trick to find a suitable crop of an image is to cut a frame out of cardboard or paper and move it over the image like a camera lens until you find a well balanced composition in line weight and colours. Since the glass nuggets should not be cut or trimmed, work in sections that you know you can finish within the working time of the adhesive. This means you can tweak the tiles and if necessary replace some of them for a better fit. Start by mosaicing the caramel coloured lines then fill in the background

areas, starting from the outside and working inwards. Use the larger pieces first, getting smaller towards the middle. When the whole mirror is finished, leave it to dry thoroughly. If you want to grout your mirror, run a line of masking tape around the edges of the mirror itself to protect it, as the grout may scratch the surface. Grout the mosaic and leave it to set. Fix a D-ring on the reverse to hang your mirror. To make the zebra mirror, follow the same instructions but using 300 white mosaic pebbles for the background and 170 black pebbles for the stripes.

DESIGNER AND MAKER:
ARENDSE PLESNER

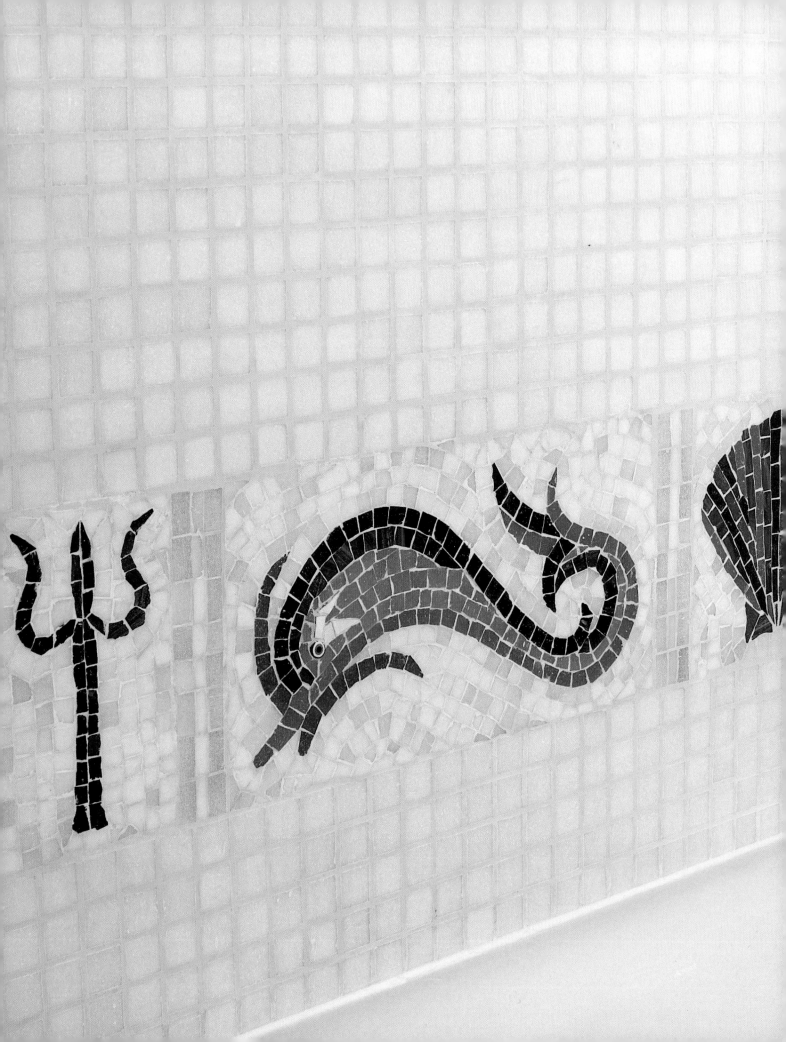

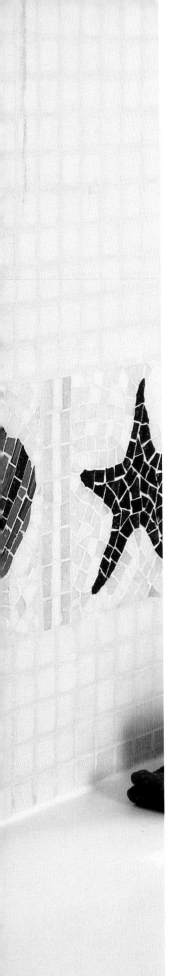

Dolphin frieze

You can make this design for any room in your home. You could also use it as a decorative border to edge tiling in a bathroom, or remove existing tiles and replace with the motifs. Each motif is 15cm (6in) square or a multiple of this, so you can replace one, two or more 15cm (6in) tiles. If your tiles are a different size, enlarge or reduce the motifs to fit. No matter how hard you try to make the motifs look exactly the same, they each have a slightly different look and different character when mosaiced – this is what makes mosaic such a wonderful craft.

Techniques
Transferring the design (page 19)
Cutting (page 20)
Working on mesh (page 24)
Grouting (page 31)

Difficulty rating
● ● ● ◌ ◌

Time scale
 2–4 days (depending on number of motifs required)

DESIGNER AND MAKER:
MARTIN CHEEK

DOLPHIN FRIEZE | 81

PROJECT 10

Materials list

15 x 60cm (6 x 24in) piece of mesh
for one of each motif

15 x 60cm (6 x 24in) piece of MDF

- **50 vitreous glass** in bright white for each dolphin
- **50 vitreous glass** in white for each dolphin
- **15 vitreous glass** in dark blue for each dolphin
- **15 vitreous glass** in dark turquoise for each dolphin
- **15 vitreous glass** in mid turquoise for each dolphin
- **15 vitreous glass** in light turquoise for each dolphin
- **10 vitreous glass** in blue vein for each dolphin
- **1 millefiori** for each dolphin eye

- **4 silver leaf smalti** for each dolphin eye
- **20 vitreous glass** in bright white for each shell
- **20 vitreous glass** in white for each shell
- **15 vitreous glass** in dark blue for each shell
- **10 vitreous glass** in mid blue for each shell
- **10 vitreous glass** in dark turquoise for each shell
- **15 vitreous glass** in blue veined for each shell
- **5 vitreous glass** in bright white for each spacer
- **5 vitreous glass** in white for each spacer
- **20 vitreous glass** in bright white for each trident

- **20 vitreous glass** in white for each trident
- **10 vitreous glass** in dark blue for each trident
- **10 vitreous glass** in blue vein for each trident
- **30 vitreous glass** in bright white for each starfish
- **30 vitreous glass** in white for each starfish
- **20 vitreous glass** in dark blue for each starfish
- **5 vitreous glass** in blue vein for each starfish

PVA glue
Tile adhesive
300g (10½oz) of grout
Cling film

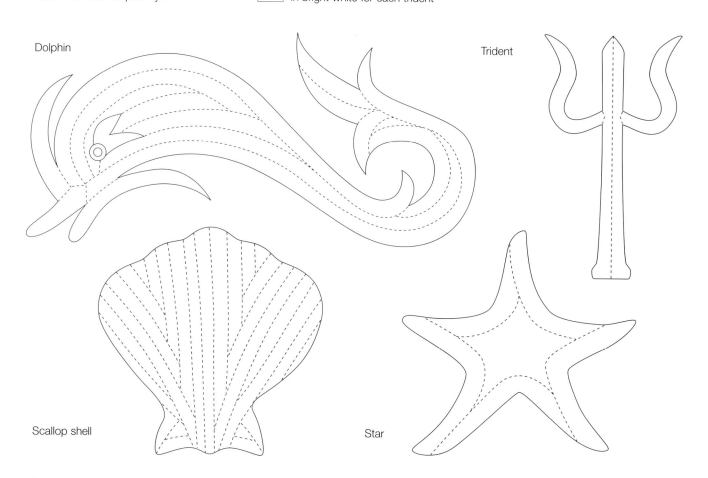

Dolphin

Trident

Scallop shell

Star

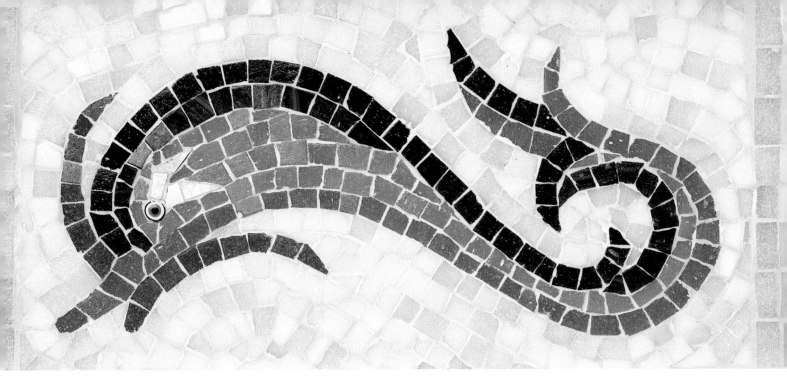

1 Enlarge the templates (opposite below) to 200% or to fit your tile size and transfer to pieces of MDF. Draw over each design with a black felt tip pen, so you will be able to see it clearly through the mesh.

2 Cover each board in cling film, so you can reuse the board to make repeat motifs.

3 Decide how many of each motif you need to make your design, then cut enough pieces of mesh for each motif. Position the mesh over the first motif and hold in place with a couple of dabs of glue. Work the key line, spending time to get it nice and neat, as it will set the rest of the design.

4 Start filling in design, working out from the key line and doing the areas in order of importance. Establish the background *opus vermiculatum* then start filling it in, working in lines that follow or complement the shape of the *opus vermiculatum*.

5 Leave the finished piece to dry overnight. The following day peel the motif off the MDF carefully and turn it over to dry thoroughly. Repeat until you have enough motifs to complete your frieze.

6 Trim the excess mesh away, and fix the motifs in position with tile adhesive. Leave to dry and then grout.

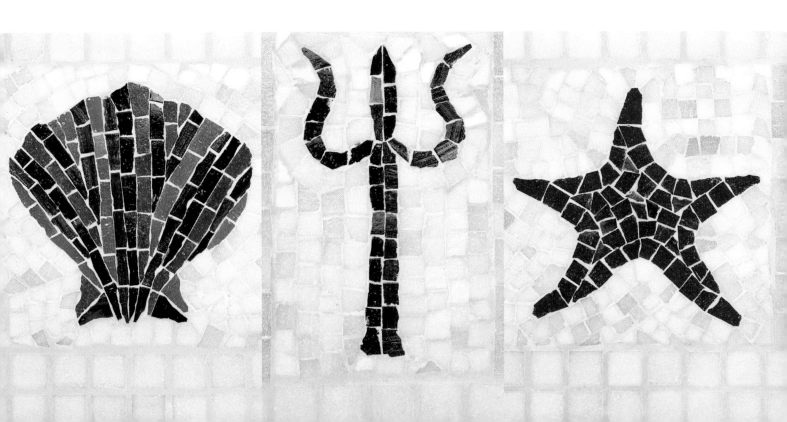

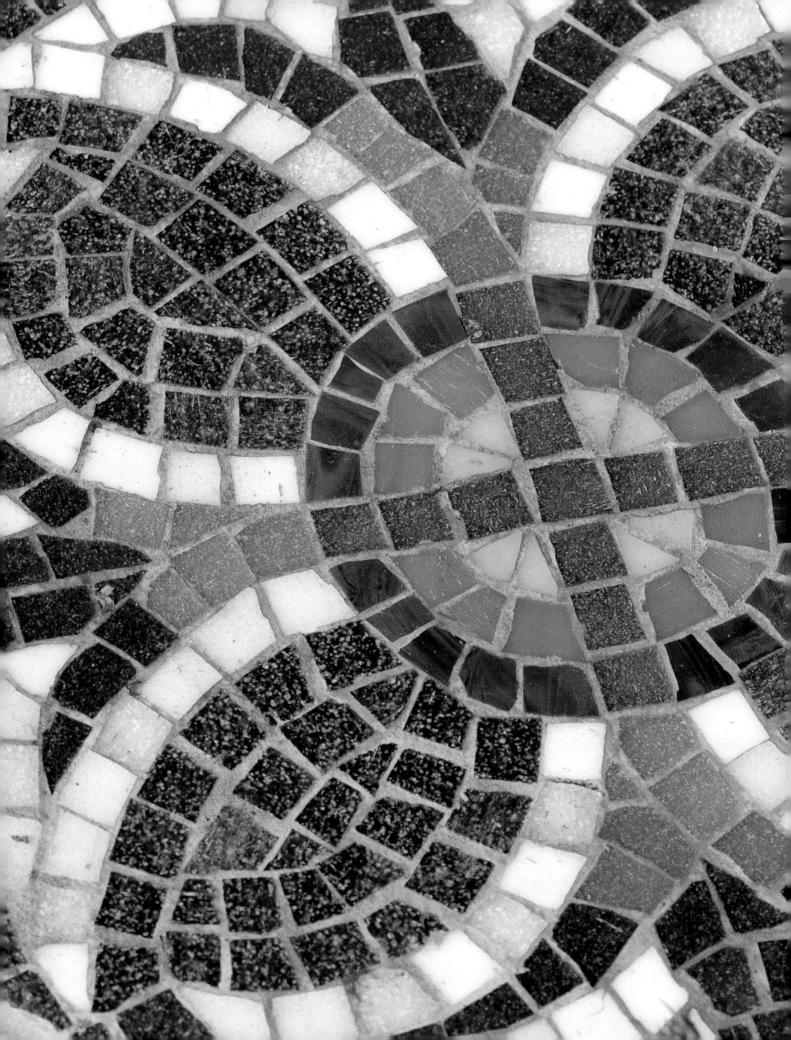

Ravenna star paving slab

This motif is inspired by the ceiling of the museum in Ravenna, Italy, which is a wonderful grid of birds and a repeating flower. I wanted to make a simple, square motif, which could be looked at from any angle. I took the flower from the ceiling pattern and translated it into this star design, which is easy to make and has a limited palette of colours (see page 32 for details on making the slab).

Materials list
Length of adhesive film
25 x 25cm (10 x 10in) piece of mesh
30 x 30cm (12 x 12in) MDF board

- 10 vitreous glass in green
- 15 vitreous glass in red
- 10 vitreous glass in orange
- 70 vitreous glass in dark grey
- 40 vitreous glass in blue
- 30 vitreous glass in white

Four pieces of 30 x 5cm (12 x 2in)
Wood for mould
300g (10½oz) of cement

Techniques
Transferring the design (page 19)
Cutting (page 20)
Indirect mosaic (page 26)
Casting a slab (page 32)

Difficulty rating
● ● ● ●

Time scale
2 days

DESIGNER AND MAKER:
MARTIN CHEEK

PROJECT 11

1 Copy the template below to the size of the slab you want to make – the one shown here is 24 x 24cm (9½ x 9½in) – and stick it down onto the base board to work on. Centre the adhesive film over the motif and tape it down.

2 Mosaic the key green line, followed by the yellow, orange and red lines. Try to form these concentric circles with 5, 3 and 2 tesserae in each quadrant as shown. Repeat for the four corners. If you imagine the design as a flower, then the blue and white areas are the petals. For a neat result, mosaic the blue outline first, making sure that the inner area is clean and not jagged. Finish the petal with four curved lines of white tesserae. Repeat for the remaining three petals.

3 Complete your work by mosaicing the background. You will notice that the background lines undulate and vary in thickness between the white curved lines – fewer thicker lines are neater than many thin fiddly lines.

4 When you have finished your motif, make a mould around it as described on page 32. Mix the cement following the manufacturer's instructions on the packet. Put a large dollop of cement into the mould and press it down gently but firmly to smooth it out across the entire area.

5 Add a piece of mesh to stabilize the slab, then add another layer of cement to cover it. Sign and date the back of the slab if you wish and leave it to dry.

6 Remove the mould, turn the slab over and peel off the adhesive film. Brush away any loose dry grout, then grout across the whole area as usual.

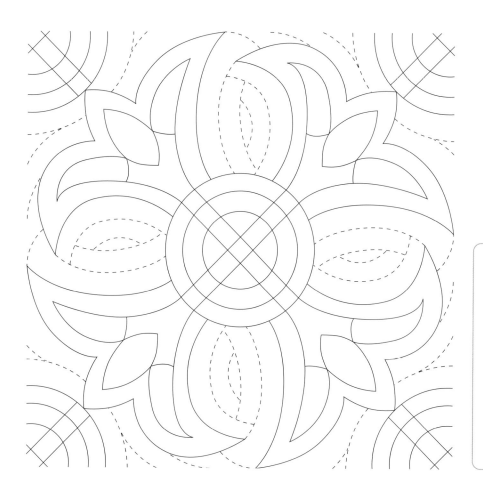

Under the weather

A great idea for this slab would be to make several and lay them in the garden in a chequerboard pattern, with herbs growing in alternate spaces. I have many mosaics installed in my garden and I love the way that they weather over the years, with plants growing over them. As an alternative design you could make a mosaic of the actual herb, or the names of the herbs.

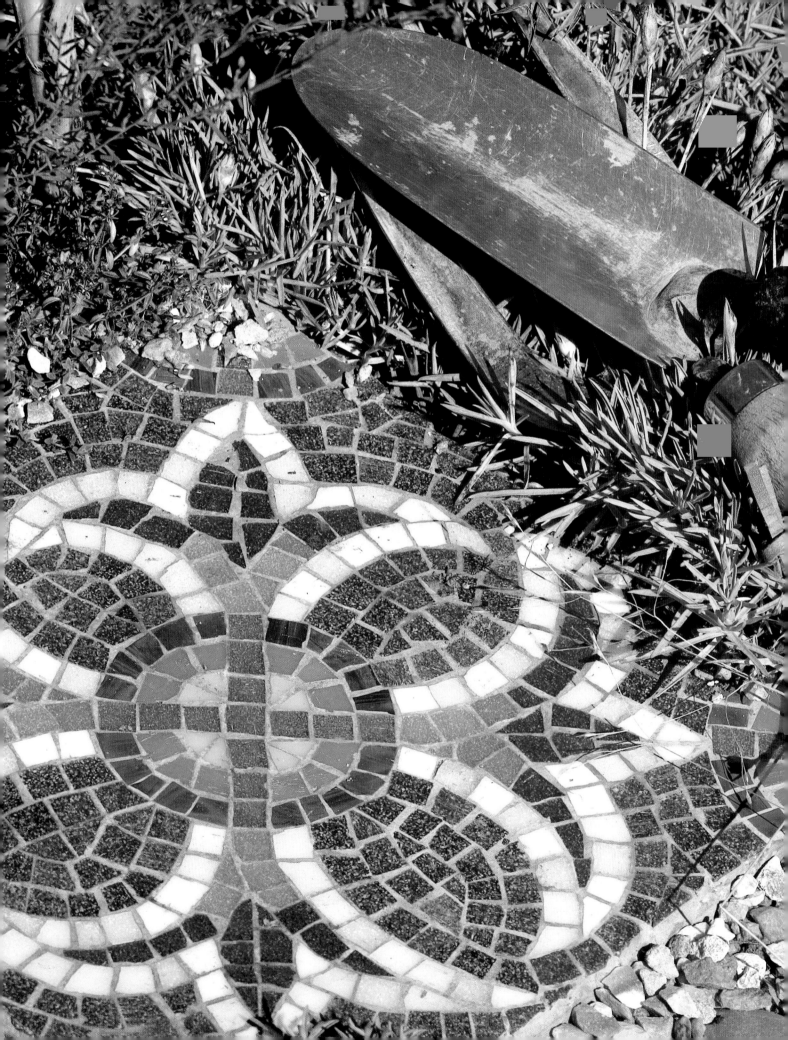

Spanish bull tile trivet

I bought this lovely bull tile in Barcelona and Arendse decided to put a row of matching smalti around the edge and dropped it into a metal trivet so it can now be used for hot saucepans. This is a great way to use odd decorative tiles, or you could make your own, as I love to do. Alternatively, you could fill the trivet with any suitable mosaic design.

Materials list

18cm (7in) square metal trivet base
1 decorative tile
Length of adhesive film

 40 assorted smalti
 to match a colour in the tile
500g (17½oz) tile adhesive
150g (5¼oz) grey grout

Techniques

Transferring the design (page 19)
Cutting (page 20)
Indirect mosaic (page 26)
Grouting (page 31)
Using metal bases (page 34)

Difficulty rating

● ●

Time scale

 1–2 hours

DESIGNER AND MAKER:
ARENDSE PLESNER

PROJECT 12

1 First take a template of the metal base, as they all vary a little in size and the angles are not always perfect. Mark one side of both template and base as the top for reference. Tape the template onto a board, and cover with adhesive film, sticky side up – you need to make this mosaic indirect to be sure the result is flat.

2 Place the tile in the middle of the template and then create a border all around in smalti, trimming them to fit as required. Leave the mosaic overnight to settle. Since the smalti has such an uneven surface it will not stick well to adhesive film because the whole surface will not touch the film, so be careful when you move it.

All change

You can also make this project with one of the other mosaic designs in this book – try one of the motifs from the Ravenna Freestanding Shelves on page 98, for instance.

3 Mix the tile adhesive and fill the trivet up to the thickness of the mosaic below the top edge. The tile plus mosaic is a bit heavy for the adhesive film to grip, but because the base is small and flat you can pick it up, turn it over and sink it in over the mosaic, rather than picking the mosaic up and placing it on the bed of adhesive as you have to with bigger pieces.

4 Carefully cut the mosaic loose from the board, flip the whole thing back again and make sure the mosaic is even and flat before you leave it to set. The adhesive needs air to dry, so this project will take quite a long time as the tile covers a large area.

5 The adhesive film will also inhibit the drying process, so carefully peel it off when you feel the adhesive has set enough and scrape out any excess that has squeezed up between the tesserae. Leave for several days to be sure it is dry enough to grout.

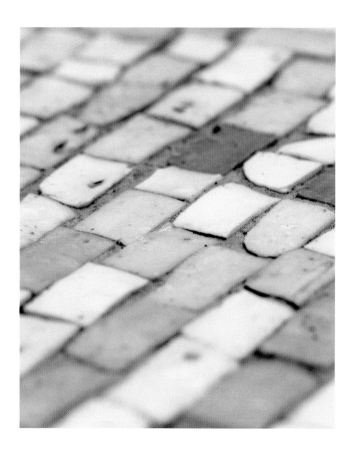

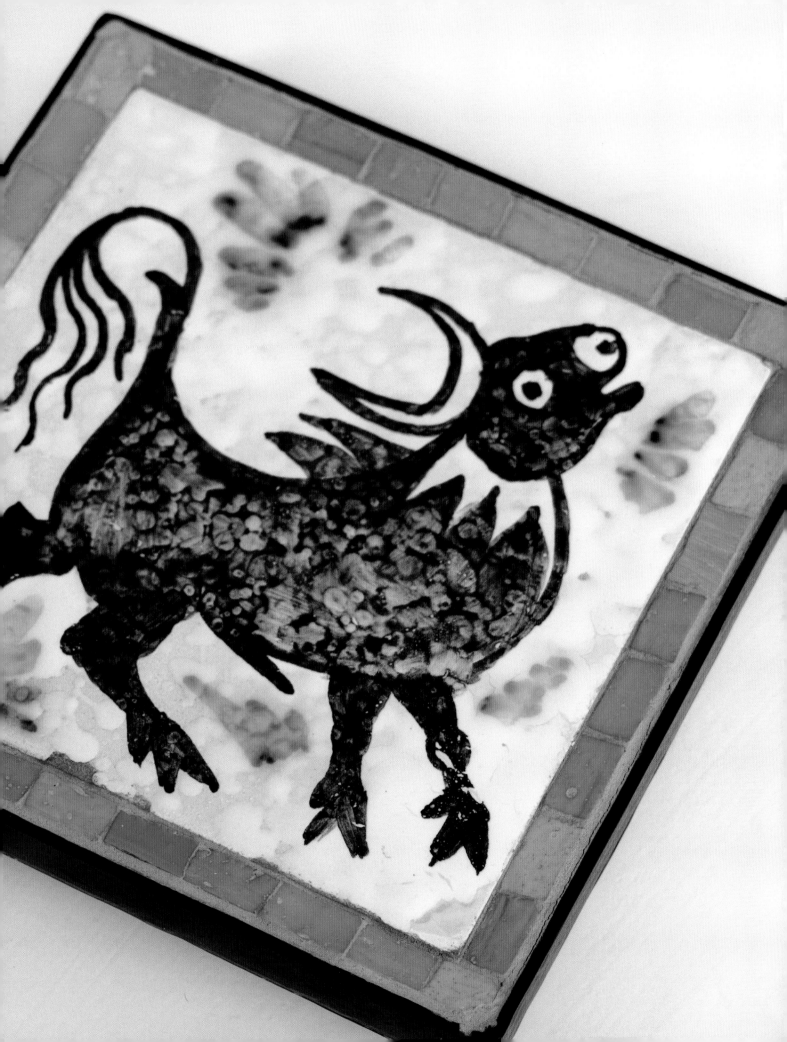

Kilim table

This table is inspired by the colours of Morocco – particularly the rugs, which are handmade and rough, but full of contrast and colour. I made my own Moroccan 'kilim' by sticking rows of tiles on a piece of MDF and the idea was later adapted into a table top by Arendse. The design uses eight colours in rows of full or half tiles, in sequences of five bands separated by a black row each time.

Materials list

56 x 31cm (22½ x 12½in) metal table
Adhesive film
For the green version:

- **180 x 1cm (³⁄₈in) vitreous glass** in colour 1 (black)
- **120 Sicis Water Glass** in colour 2 (olive)
- **150 x 1cm (³⁄₈in) vitreous glass** in colour 3 (purple)
- **90 Sicis Iridium** in colour 4 (iridescent black)
- **60 x 2cm (³⁄₄in) vitreous glass** in colour 5 (off-white)
- **150 x 1cm (³⁄₈in) vitreous glass** in colour 6 (light purple)
- **40 x 2cm (³⁄₄in) vitreous glass** in colour 7 (emerald green)
- **150 x 1cm (³⁄₈in) vitreous glass** in colour 8 (light green)

4kg (9lb) tile adhesive
400g (14oz) grey grout

Techniques

Indirect mosaic (page 26)
Grouting (page 31)
Using metal bases (page 34)

Difficulty rating

● ● ● ●

Time scale

◖ 2 days

DESIGNER AND MAKER:
MARTIN CHEEK AND ARENDSE PLESNER

PROJECT 13

1 The template below shows the order of the colours, but adapt it as necessary to fit the length of your table. Make sure that the finished mosaic will be slightly smaller than the inside of the metal base, so it will fit inside. Tape the template down on a base board and cover with a sheet of adhesive film, sticky side upwards, taping the film in place.

2 Starting from one short side, work your way across the table, working towards the middle. Don't worry if your rows are not perfect, you want the finished table to look handmade.

3 Leave the design overnight so the tiles have time to settle onto the film. Set the mosaic into the table as described on page 34.

4 Remove the adhesive film, scrape out the excess adhesive as described on page 35, and leave the table to dry thoroughly before grouting.

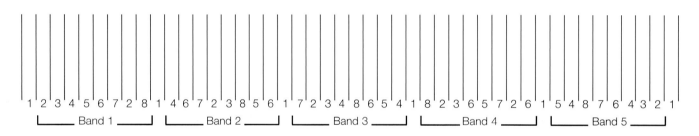

1 2 3 4 5 6 7 2 8 1 4 6 7 2 3 8 5 6 1 7 2 3 4 8 6 5 4 1 8 2 3 6 5 7 2 6 1 5 4 8 7 6 4 3 2 1

L___ Band 1 ___J L___ Band 2 ___J L___ Band 3 ___J L___ Band 4 ___J L___ Band 5 ___J

Order of colours

Red alert

It is easy to adapt the colours to match your own interior but five bands of colour of a similar width are essential to balance the design. To make the red version shown on page 93, colour 1 is black, colour 2 is red, colour 3 is olive green, colour 4 is orange, colour 5 is yellow, colour 6 is white, colour 7 is blue and colour 8 is green.

Don't worry about getting the lines perfectly straight, as if drawn with a ruler. Slightly wavy, uneven lines will resemble a handmade carpet!

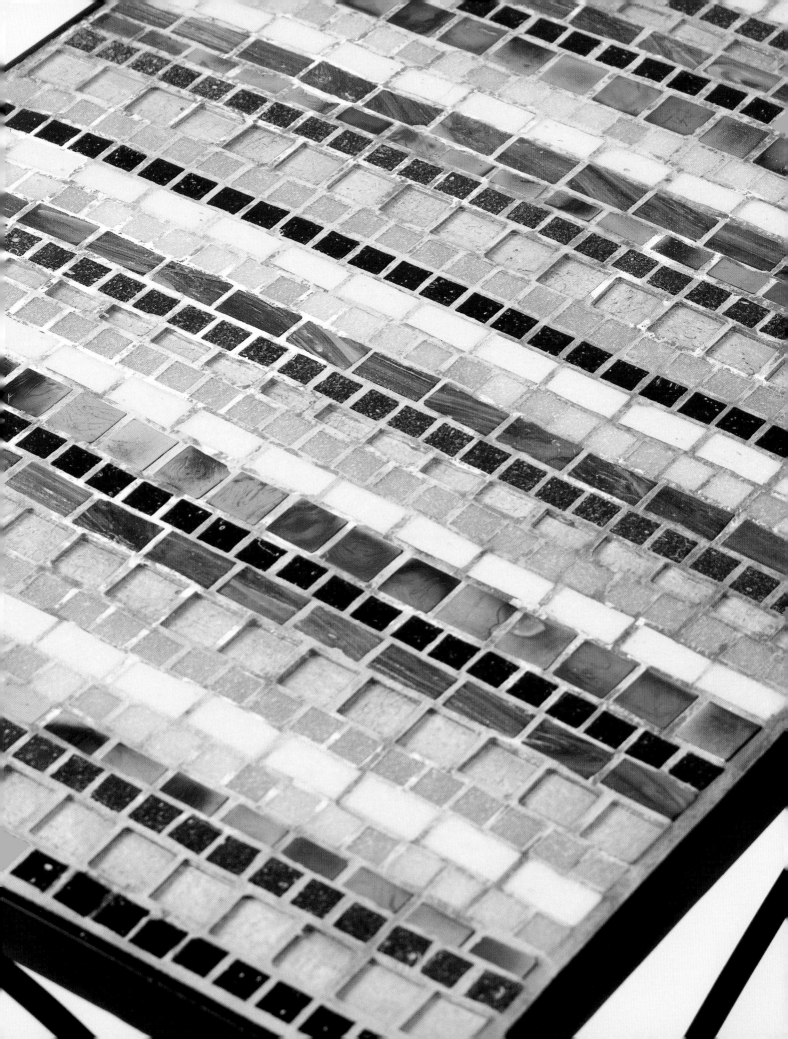

minute mosaic

Letters for children's room

Most children like to personalize their rooms and they love their initials on the door so that everyone can see it is their territory. Glass pebbles have no sharp edges so your children could make this project themselves. An outdoorsy son could use woodland browns and greens, a daughter who loves bright things could have brilliant red or rainbow colours.

Materials list

30 x 30cm (12 x 12in)
piece of MDF

 22 mosaic pebbles in brown

 134 mosaic pebbles in green

 24 mosaic pebbles in caramel

1 small D-ring

Techniques

Transferring the design (page 19)
Direct mosaic (page 22)
D-rings (page 36)

Difficulty rating

Time scale

 2–4 hours

Choose your letter and enlarge it to about 30cm (12in) high, trace it onto a piece of MDF and cut it out with a jigsaw. If you prefer you can draw the letter onto mesh, mosaic it, cut it out and stick it straight onto the bedroom door. It is easier to make a large letter than a small one and when there is no cutting involved the result will be better. Spread out the glass pebbles so you can see what you have to work with, then choose and stick down the corner pieces first. Make the outline using the larger pieces then fill in the remaining area using the smaller pieces – which is rather like doing a jigsaw puzzle. It is good to finish the entire letter in one go, because then you can tweak the pebbles whilst the glue is still wet. Since the piece is intended for indoor use and has no sharp corners you don't need to grout it if you don't want to. Paint the edges in a colour matching the tiles. Fix a D-ring to the reverse side and hang the letter up on your child's door. For the bright letter, you will need 180 pebbles in two shades of your child's favourite colour.

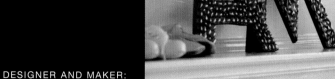

DESIGNER AND MAKER:
ARENDSE PLESNER

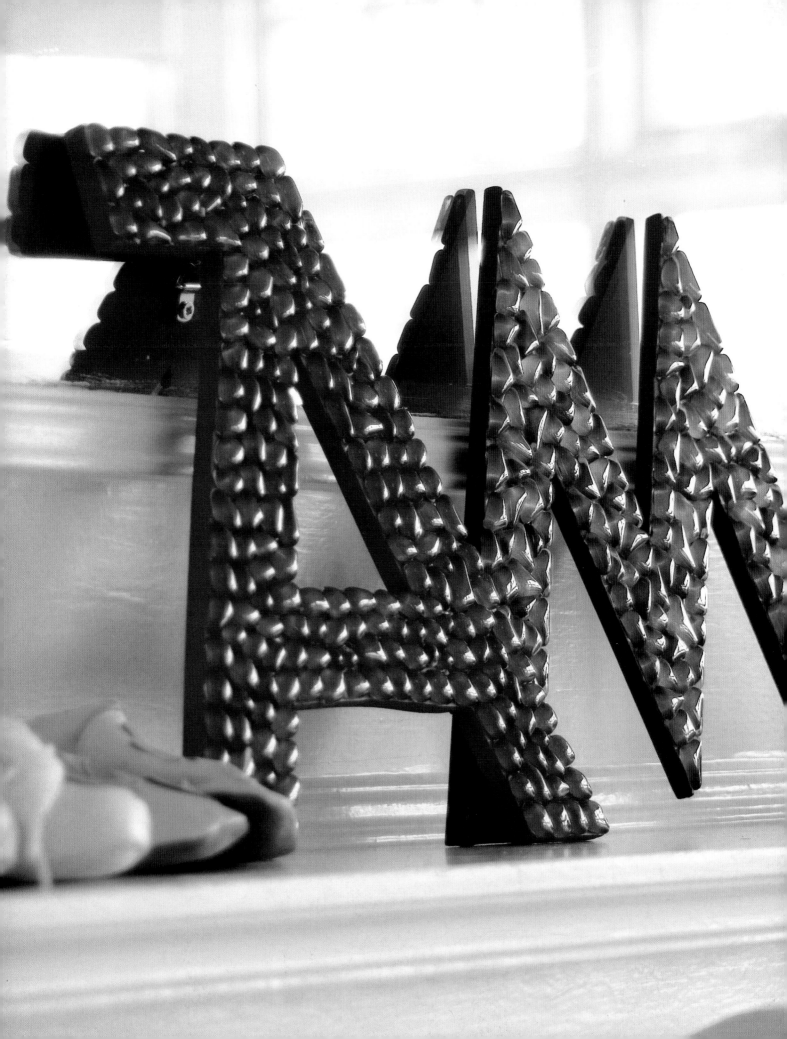

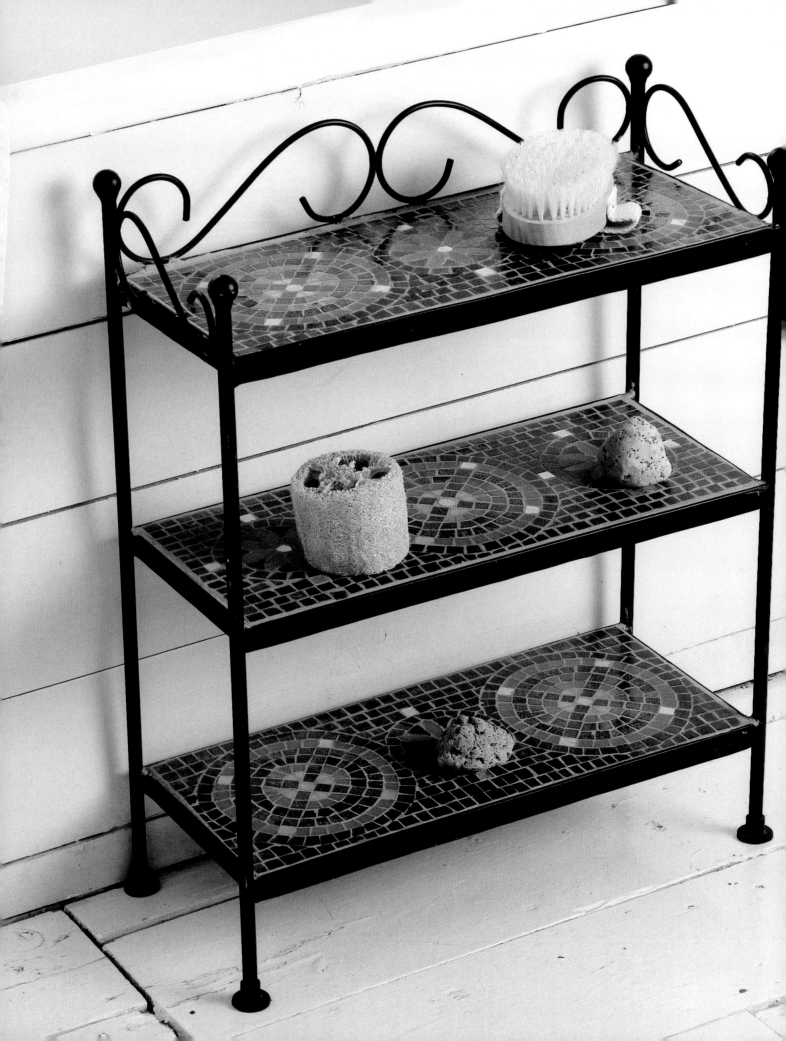

Ravenna Freestanding Shelves

The inspiration for this was the ceiling of the Galla Placidia Mausoleum in Ravenna, Italy – a dream-like design of snowflakes, or like looking up to a heaven full of celestial stars and beyond to eternity. Here, the design is used for an earthly three-shelf trivet for herb pots, trinkets or household items – the evenly-spaced stars position them nicely!

Materials list

17 x 40cm (6¾ x 16in) shelf base
Adhesive film
20 x 45cm (8 x 18in) MDF base
board

- **15 vitreous glass** in green for stars
- **10 vitreous glass** in yellow for stars
- **15 vitreous glass** in orange for stars
- **15 vitreous glass** in brown for stars
- **25 vitreous glass** in dark grey for stars
- **200 vitreous glass** in dark blue for background
- **75 vitreous glass** in mid blue for flowers and outlines

15 gold smalti for highlights
4kg (9lb) tile adhesive
400g (14oz) grey grout

Techniques

Transferring the design (page 19)
Cutting (page 20)
Working on mesh (page 24)
Grouting (page 31)
Using metal bases (page 34)

Difficulty rating

● ● ● ●

Time scale

 2–3 days

DESIGNER AND MAKER:
MARTIN CHEEK

PROJECT 14

1 Enlarge the templates below to a suitable size, cut them out and insert them into the top shelf to check that the finished mosaics will be slightly smaller than the inside of the metal base. Tape each template down on a base board and cover with a sheet of adhesive film, sticky side upwards, taping the adhesive film in place.

2 Mosaic the key green cross with gold tesserae in the middle and at the end, with four green tesserae radiating outwards, each one connected with a yellow, orange, brown and dark grey circle. Try to form these concentric circles with 2, 3, 4 and 6 tesserae in each quadrant, as shown. Repeat for the star on the other side.

3 The blue central flower is made by cutting a circle from a 1 x 1cm (⅜ x ⅜in) gold leaf smalti tessera and radiating eight petals from it. These are made by imagining the petal lying diagonally across the 2 x 2cm (¾ x ¾in) vitreous glass tile and nibbling the corners off the tile accordingly.

4 The *opus vermiculatum* in this case is a surrounding blue circle. The background is then added in horizontal straight lines that crash into those circles. Repeat for the other two shelves. The top and bottom shelf are the same, but for variation I have changed the middle shelf to have one star in the middle with a flower on either side.

5 Set the mosaics into each of the shelves as described on page 34.

6 Remove the adhesive film, scrape out the excess adhesive as described on page 35, and leave the table to dry thoroughly before grouting.

Star template Flower template

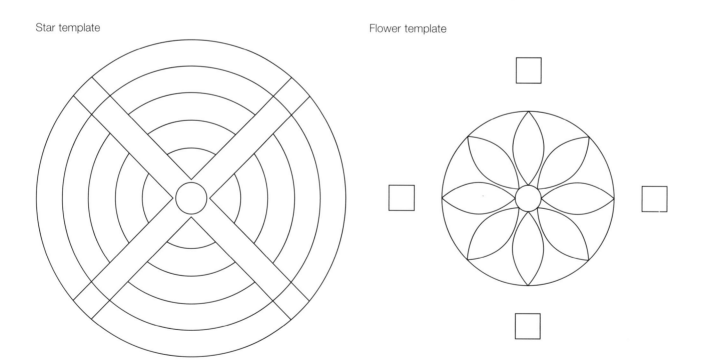

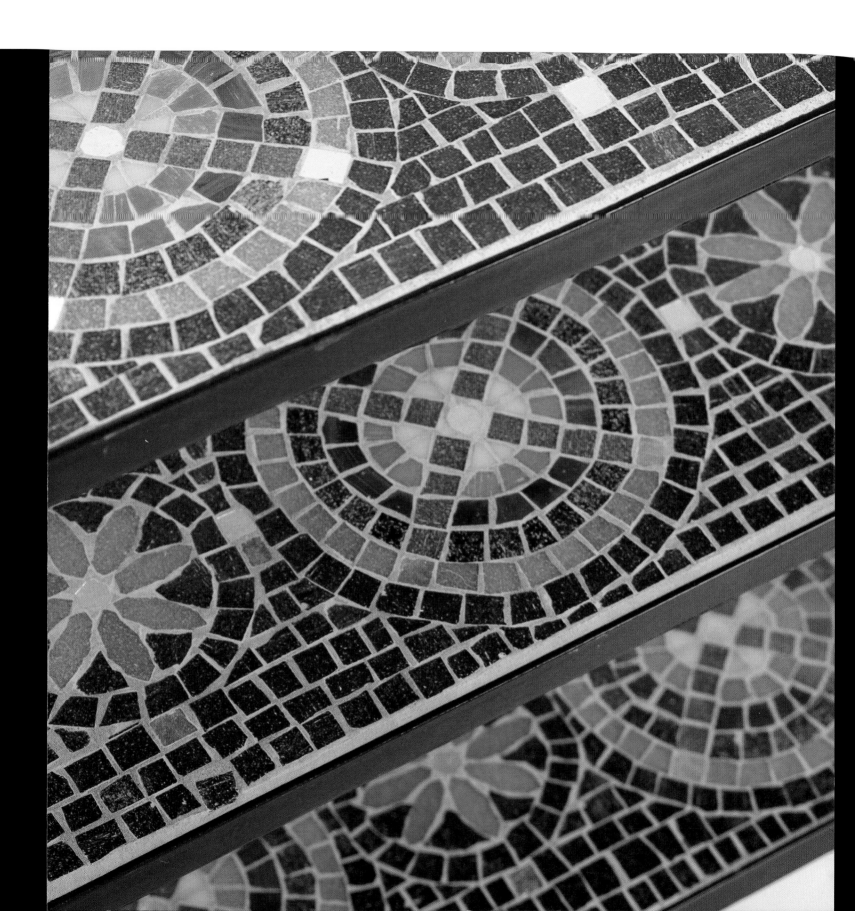

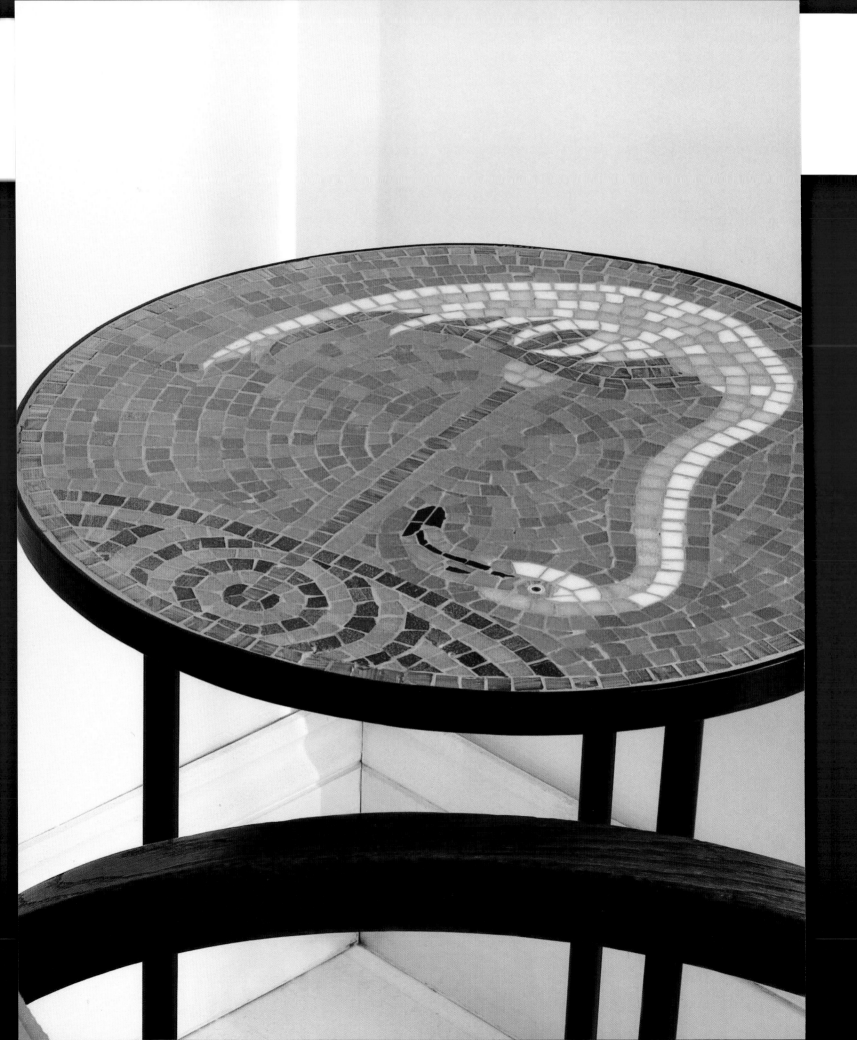

Flamingo side table

This is an old design of mine that I keep coming back to because it is very evocative for me. My son Tom is now a typical teenager, but when he was a sweet toddler I took him to the zoo for the first time. He saw a flamingo and turned to me, full of excitement, to say, 'Look at that bird sitting on a stick!' So this design and its companion table depict a bird sitting on a stick.

Materials list

For one table:

42cm (16¾in) round metal table base

Adhesive film

50cm (20in) square MDF base board

 50 vitreous glass
in copper vein for border

 10 vitreous glass
in candy pink for beak

 5 vitreous glass
in black for beak

 60 vitreous glass
in white for body

 25 vitreous glass
in pink vein for underbelly and legs

 260 vitreous glass
in assorted blues for sky

50 vitreous glass
in assorted greens for water

1 millefiori
for eye

4kg (9lb) tile adhesive

400g (14oz) grey grout

Techniques

Transferring the design (page 19)

Cutting (page 20)

Indirect mosaic (page 26)

Grouting (page 31)

Using metal bases (page 34)

Difficulty rating

● ● ● ● ●

Time scale

● 5 days

DESIGNER AND MAKER:
MARTIN CHEEK

PROJECT 15

1 Since you are making this mosaic as a table top you will need to work indirect to ensure a flat smooth finish. Copy the template on page 105 to the correct size to fit the table. The metal table bases vary slightly in size, so try the finished template face down in the tray to make sure that it fits with at least 3mm (⅛in) of space all around. Do the same for the bottom triangular shelf.

2 Make a mark on both table base and template with a strip of adhesive tape, so you can position the finished mosaic correctly. Tape the template onto a base board, then fix adhesive film on top, sticky side up.

3 Begin by putting a line of copper veined tiles around the outside edge. Place the millefiori eye in position, rotating and moving it around until you get an expression that you like – a small movement can completely change the attitude of the flamingo.

4 Now mosaic the circle that surrounds the eye. First make a circular shape in pink, trying to get it as neat as possible because it will help to define the character of the flamingo. When you are happy with your circle shape, cut it in half and then in half again, laying the quarter circles down on the table in order so that they still fit together into the circular shape.

5 Next nibble the point from each quarter circle, so now your circle shape has a an empty centre; glue the four pieces in order around the millefiori pupil. Add the beak, then mosaic the key lines of the flamingo's back and neck. Make these lines strong and flowing as they define the rhythm of the entire mosaic. Add the rest of the white tesserae to finish off the head.

6 Mosaic the wing, noticing how the lines curve gracefully into the tips of the feathers in each case. Add the underbelly using the pink veined tiles. Mosaic the leg starting at the top. Try and get this line as straight and neat as possible. The flamingo is now complete.

7 Mosaic the water in alternate dark and light rows of various greens and viridian to give the effect of a rippled surface on the water. Put in the *opus vermiculatum*, using just the one shade of blue tile for the sky.

8 Complete your work by mosaicing the sky using two shades of blue. Work in concentric circles, from the outer edge inwards, crashing into the *opus vermiculatum*.

9 On the triangular bottom shelf, mosaic the edge with the copper veined tiles, then use a mixture of the tiles used in the water on the table top for central area. Set the mosaic into the table as described on page 34.

10 Remove the adhesive film, scrape out the excess adhesive as described on page 35, and leave the table to dry thoroughly before grouting.

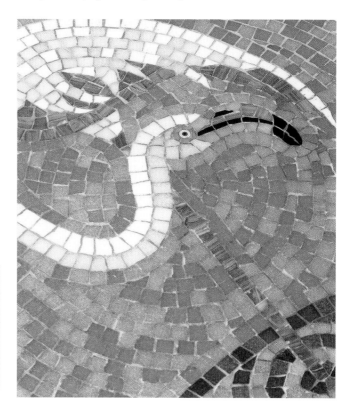

Child's eye view

A throwaway phrase from a child can often give you a different way of seeing things, which can inspire you to come up with new designs. Lots of birds stand on one leg – herons for instance – but because the flamingo has such long, spindly legs it is the one we immediately think of.

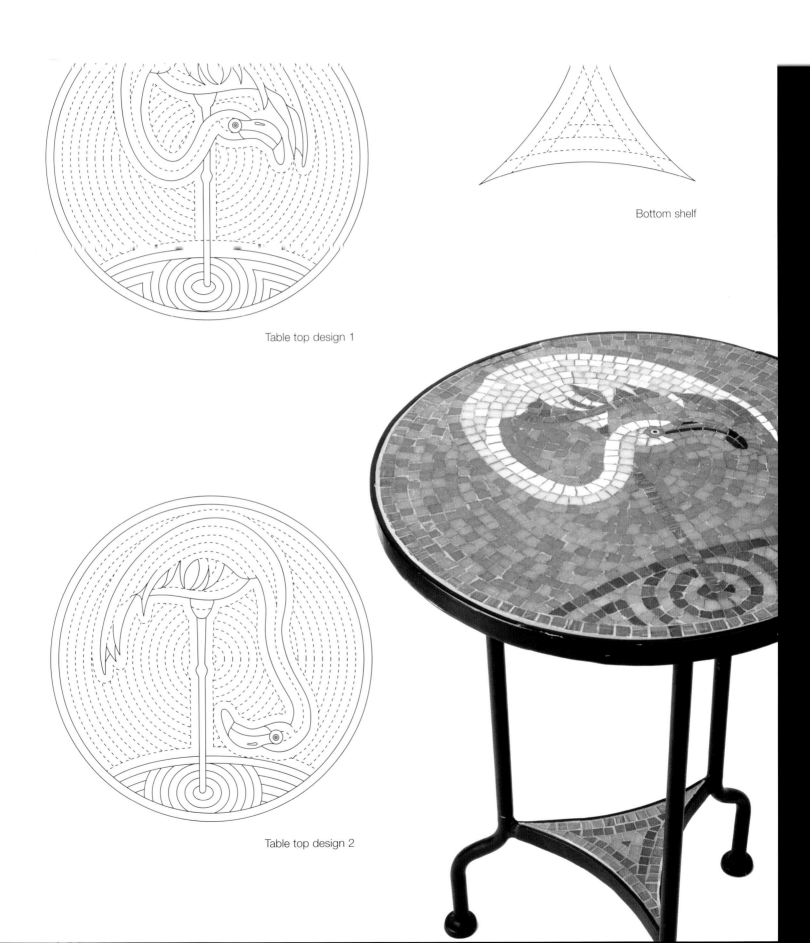

Table top design 1

Bottom shelf

Table top design 2

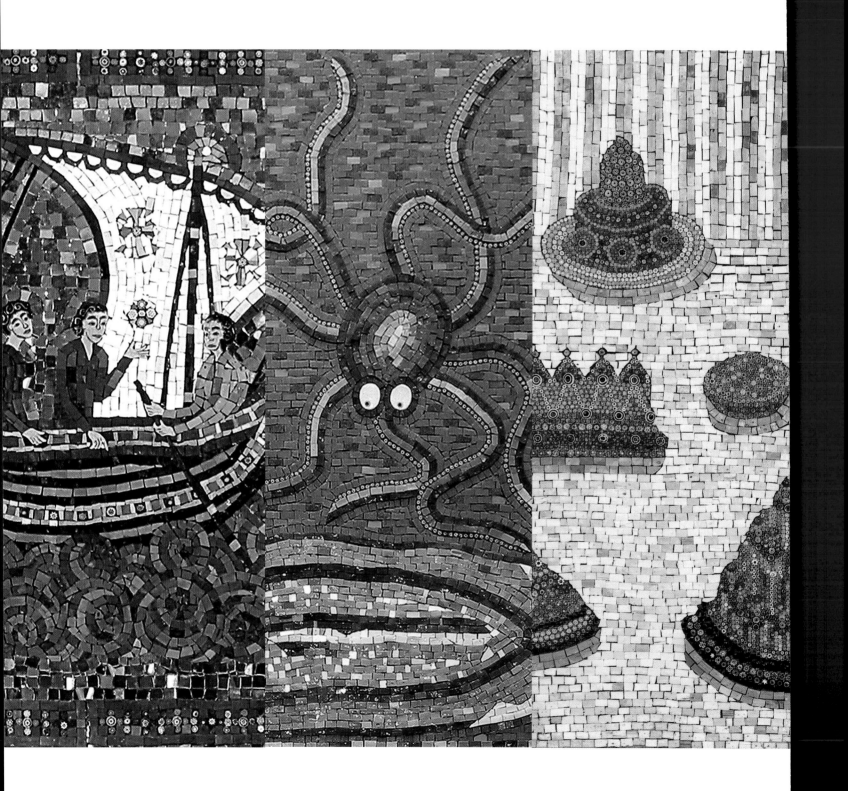

Gallery

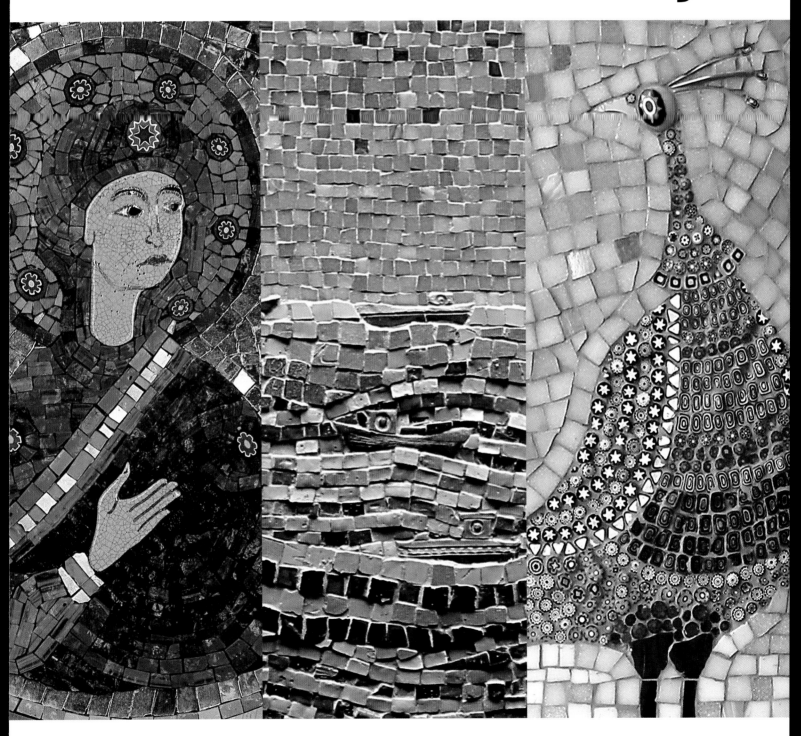

Gallery

This section shows some of the projects I have been working on over the last few years – it includes both small, personal pieces, and some much larger commissions. Some, such as the Riverhead Triptych on this page, and Ramsgate Harbour on page 125, have been created in conjunction with others, which is always an inspiring process.

Riverhead Triptych

Smalti, millefiori, smalti/millefiori fusions and handmade ceramic elements set in metal trays
Three Panels, each 150 x 180cm (60 x 72in)

This series of mosaics for the Riverhead School in Kent, England, involved getting the pupils – who were only six years old – to draw onto pre-rolled out clay. After these had been cut out and bisque fired, I returned to the school with non-toxic glazes – the kind that you get in 'paint your own pottery shops' – for the children to glaze their pieces. The mosaic triptych shows a beach scene at low, mid and high tide. The children's instructions were to make elements that are in the air, go on or in the sea and on the beach. This resulted in wonderful birds, ships, swimmers, fish, octopus, seaweed, shells, sandcastles and children playing beach activities.

Byzantine Fishermen

**Smalti, millefiori, gold mirror and handmade ceramic
elements set in a metal tray
83 x 81.5cm (33 x 32½in)**

This mosaic is inspired by a detail on the Pala D'Ora – the Gold altarpiece in St Mark's Cathedral, Venice, Italy, which dates from the thirteenth century. It shows the translation of St Mark's body. On the stylized sea, with wheel-like waves, runs a sailing ship shoved by the wind, and the sails wear the symbols of Christianity. I have used handmade ceramic elements for the faces and hands and incorporated them into a mosaic made of smalti, millefiori and gold mirror.

(52 x 51in)

These panels are carefully designed
to give depth, with a clearly defined
foreground, middle distance and
background. A carefully placed animal is
found in the foreground of each panel,
leading the viewer into the picture: a
toad in the Spring panel; an otter in the
Summer; a pheasant in the Autumn; a
heron in the Winter. Churchill School was
a new primary school in Hawkinge, Kent,
England, so funding for the project was
through the 'percentage for art' scheme,
whereby in the United Kingdom a new
public building can apply for money for
a single work of art. Preparatory work
started when I spent a week working
in the school with the children. We
discussed the changes that come about
as the seasons evolve, when animals and
plants undergo their own changes in
behaviour to adapt to the developing
seasons. Out of this came ideas for the
design of the completed panels. Each
panel includes a tree inspired by the
children's work.

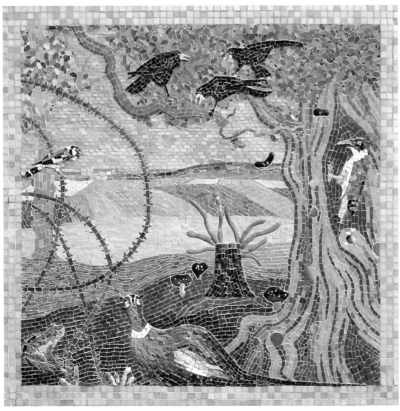

'Day of the Dead' Mosaics

Mexican smalti and millefiori on board
Cat: 77 x 53cm (30 x 21in), Dog: 60 x 59cm (24 x 23½in),
Market Lady: 77 x 76.5cm (31 x 30½in), Horseman: 120 x 90cm (48 x 36in)

Since seeing an exhibition celebrating the Mexican 'Day of the Dead' at the (sadly defunct) Museum of Mankind in London, England, about 15 years ago, I have been fascinated by the way skeletons can be used to create such gay, colourful and outright fun imagery – far removed from that of Edgar Allan Poe and those corny Hammer horror flicks of my childhood. The images and sculptures from that exhibition stuck in my memory and became a fixation for me. I was in Mexico recently working at a mosaic factory in Cuernavaca and one of the thrills was finally being able to visit the actual country where those celebrations took place. Unfortunately I wasn't able to be there for the Day of the Dead Festival, which takes place at the beginning of November, but I was able to collect some imagery and figurines connected with it – which became the inspiration for this mosaic.

Majolica Fish

Millefiori and millefiori fusions, gold leaf smalti and vitreous glass on board 80cm (32in) diameter

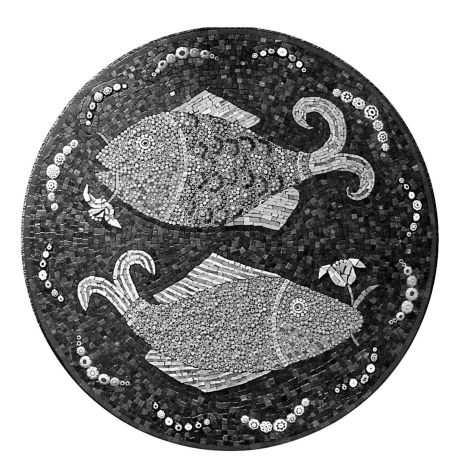

This mosaic was inspired by visiting the Victoria & Albert Museum in London, England. The first time one visits any museum there is a tendency to run around like a headless chicken, trying to see all that it has to offer. Of course it is important to know the scope and range of the collection, but I find that in trying to see everything one ends up remembering nothing. My method is to take notes on the initial visit and on subsequent visits to concentrate on one subject only. For example, on my last visit to the V&A, I wanted to study their extensive collection of Majolica-ware. Thanks to this limited personal brief I didn't feel pressured into feeling that I was missing any of the other exhibits. I stayed for just over an hour and as a result took in quite a lot, making notes and sketching details as visual reminders where necessary. If I'd have stayed six times longer, I really believe that I would probably only have achieved twice as much. I find these short bursts more productive, more enjoyable and more memorable as I recall 'that was the day when I looked at the Majolica.'

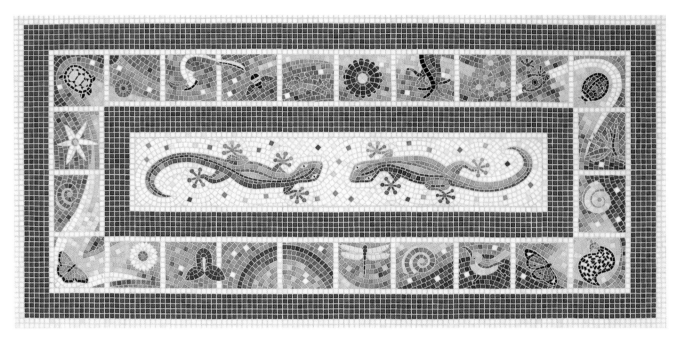

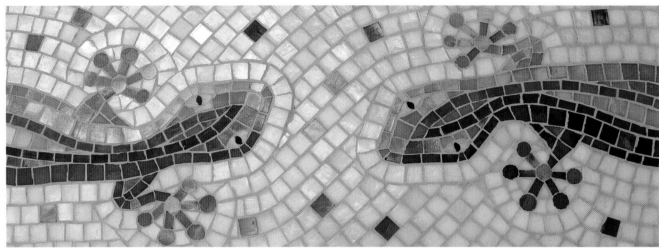

South African Table

Sicis Iridium, Smalto and Water Glass set in metal frame
210 x 100cm (48½ x 12½in)

This table by Arendse Plesner, based on the work of an unknown African artist, started out as a repair commission – the client's original mosaic table had been made with low-fired ceramic tiles that had not stood up well to the English winter. However, the table proved impossible to repair so the client asked Arendse to remake it, keeping the existing overall feel and using lots of bright colours. She adapted the original design to incorporate more South African flora and fauna and create the new mosaic in her own style. All of a sudden it became a dream job that Arendse really enjoyed making. The actual mosaic was made on adhesive film in Arendse's studio in square sections and fixed on site as described on page 34. How long did it take? Well, you are looking about 6 weeks solid work!

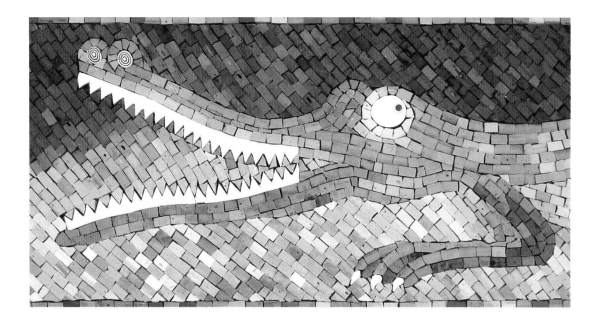

Crocodile & Toucan

Smalti, millefiori and handmade ceramic elements
122 x 31cm (48½ x 12½in)

I am often asked what the inspiration is behind my work. Well the inspiration behind this piece is thrift! The metal for the trays comes in sheets and, having taken two large square pieces from a single sheet, I had a long narrow bit left. It was this shape that made me think of making a crocodile and the toucan on his tail with its long beak helps to emphasize the whole effect. The beak and the croc's teeth and eyes are ceramic elements that I made especially. I had to stop work on the croc because his eyes weren't right and wait until I'd made a simpler pair – these new ones give him a very knowing look, innocent but wicked at the same time Often when I'm not happy with a piece it's because it is too complicated – which means it needs simplifying. People think that simple means easy but it doesn't in my case – I find getting a design to look this simple is really difficult! As George Bernard Shaw once said 'I wrote you a long letter because I didn't have time to write you short one'!

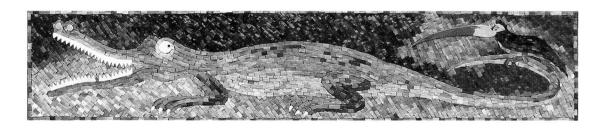

Startled Owl

Smalti, gold leaf smalti, millefiori, ceramic and
beach glass on board
38 x 30cm (15 x 12in)

Owls are among my favourite birds as they are so full of character. I was once
looking at some very sleepy owls when one of them opened one eye, turned around
and looked at me. It made me feel as though I had disturbed it and I later tried to
capture that feeling in mosaic – this is the result.

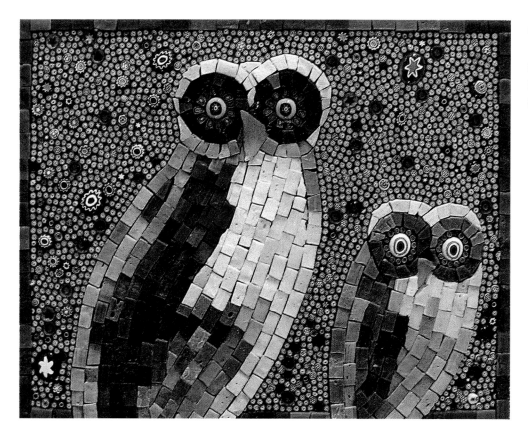

Owls

Smalti and millefiori on
board
38 x 30cm (15 x 12in)

Turkey Toy

Smalti, gold leaf smalti, millefiori and vitreous glass on board
30 x 28cm (12 x 11in)

I love collecting ceramics, toys and other odd artifacts where the characterization of an animal is well observed. Things like those nodding terrapins that you see everywhere. This mosaic is a pretty straight 'portrait' of one such curio, this time a tiny nut that had been hollowed out with waving legs hooked to the inside of the shell. Although I picked this toy up in New Zealand, I'm pretty sure that it was made in China. I made it in mosaic because I thought it would make an interesting companion piece to the Christmas Turkey below.

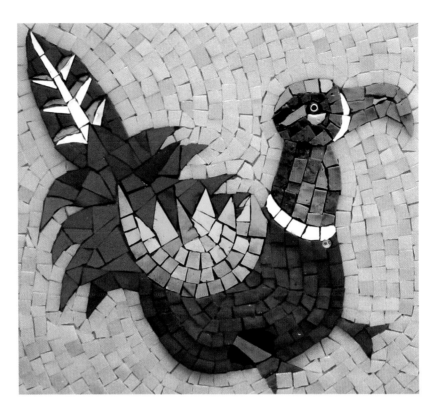

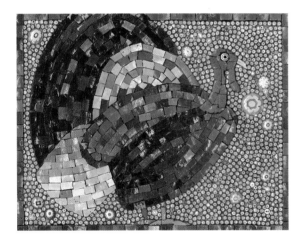

Christmas Turkey

Smalti and millefiori on board
38 x 30cm (15 x 12in)

Those bronze turkeys that are especially enjoyed over Christmas in the UK and elsewhere, and Thanksgiving in the US, are simply immense when you see them alive and close up. They are not very clever – if one were to slip and fall over in a pool of water, it would drown before it summoned up the intelligence to get up. But just because something isn't clever it doesn't mean that it can't be intimidating and imposing – as to my mind turkeys certainly are. I was trying to capture that irony here as well as creating a festive look to use as a Christmas card.

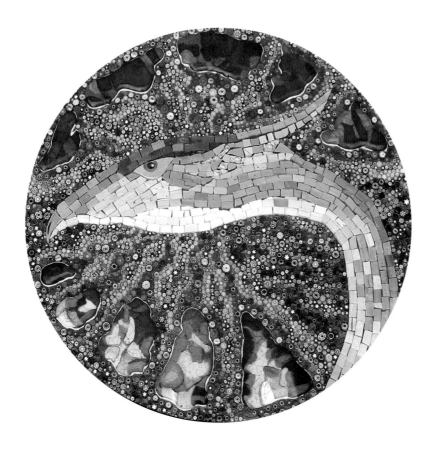

Phoenix Head

Millefiori, smalti and glass fusions on board
50cm (20in) diameter.

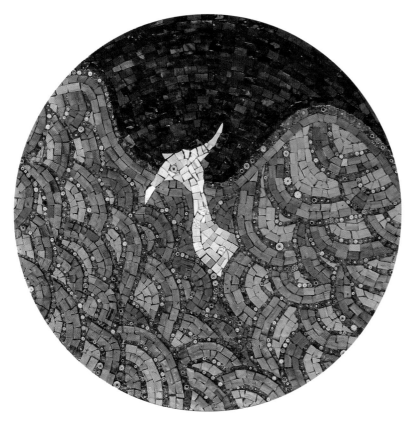

Phoenix Rising

Millefiori, gold leaf smalti and smalti on board
50cm (20in) diameter.

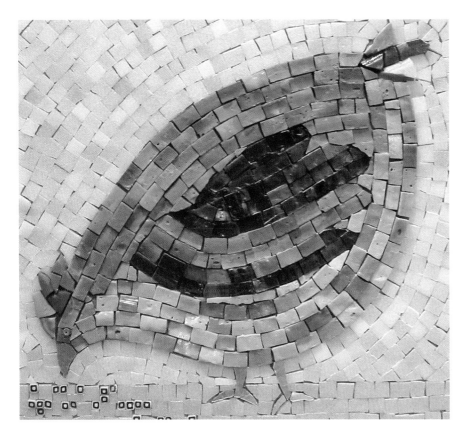

Corn Fed Chicken

Smalti, millefiori and vitreous glass on board
30 x 28cm (12 x 11in)

I think that the plumpness of the chicken above is emphasized by the tightness of the format of the actual mosaic. Those square yellow millefiori are a gift for this mosaic, looking so much like actual niblets of corn. I also like the intentness with which she is pecking away.

Peacocks (The Four Elements)

Millefiori, gold leaf smalti and smalti on board
Four Panels, each 30 x 30cm (12 x 12in)

I am proud to be a member of BAMM (British Association of Modern Mosaic). Each year they hold an annual open exhibition for all their members and the theme for last year was the four elements: Fire, Water, Air and Earth. I decided to make my contribution four peacocks, each identical in design but in different colourways to represent each element. Most people probably don't realize it but peafowl come in many colours: green, brown and white as well as the traditional turquoise. I suppose that the red one should have been a firebird – but then they wouldn't have all been the same would they?

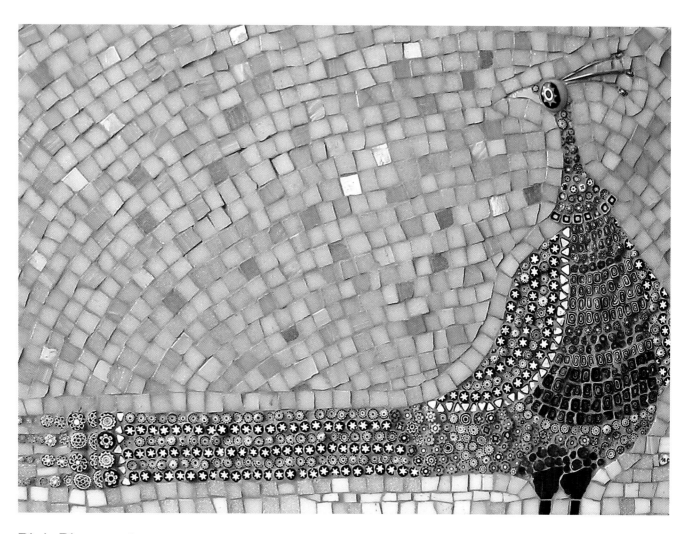

Pink Pheasant

Millefiori, gold leaf smalti and vitreous glass on board
42 x 29cm (16½ x 11½in)

I have always loved pheasants and was thrilled one day to buy two pairs. My reason for admiring them so much was the fact that the male appeared to be wearing a beautiful Venetian mask. Unfortunately when I opened the cage to transfer them to their pen one male immediately flew away – only to be joined by his pal a few days later. I was left with two frustrated and angry females, who settled into widowhood with the chickens, playing nursemaid to any chicks that would put up with them!

Green Pheasant

Millefiori, gold leaf smalti and vitreous glass on board
45 x 30cm (18 x 12in)

This mosaic depicts the 'green and pheasant land' that I used to sing about in school in England.

Blue Pheasant

Millefiori, gold leaf smalti and vitreous glass on board
38 x 30cm (15 x 12in)

These mosaics are only loosely based on those real silver pheasants, in the same way that all of my birds are not really meant to be natural history studies – it's the attitude and character of the bird that I'm after and I'm quite pleased with the result of this one. I was trying to capture that look of complete bewilderment – so elegant yet so dumb.

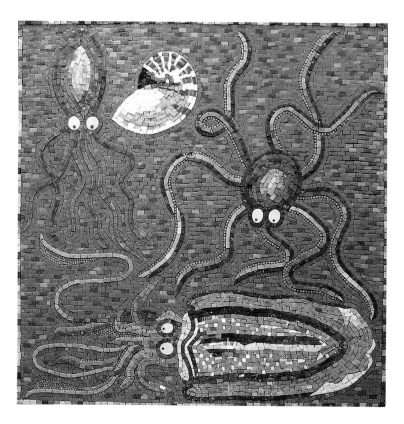

Cephalopods

Smalti, gold leaf smalti, millefiori and vitreous glass set in a metal tray
100 x 100cm (40 x 40in)

Over the years I have mosaiced many octopus and quite a few squid so I thought it might be fun to compose a piece using all four Cephalopods: the octopus, squid, cuttlefish and nautilus. 'Cephalopod' literally means 'head footed' because the feet of the creature emerge from the head. The octopus and squid are admittedly very cartoon-like because of the eyes, but are in fact very closely inspired by similar fourth century Roman examples in the floor in Aquileia, Northern Italy.

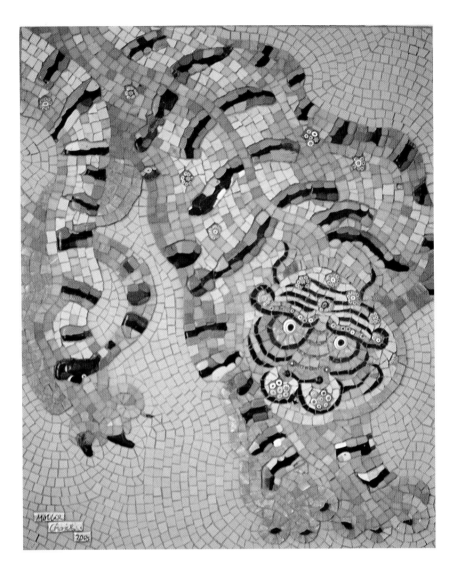

Turks Tiger

**Charcoal Mexican smalti, smalti fusions, millefiori and
cinca ceramic set in a metal tray
60 x 75cm (24 x 30in)**

This mosaic was inspired by a drawing made by my daughter, Mollie, after a visit to 'The Turks' exhibition at the
Royal Academy in London, England.

Tea Time

Smalti and millefiori set in a metal tray
116 x 90cm (46 x 36in)

This piece is inspired by *Mrs. Beeton's Book of Household Management*, the original 1919 version of which has splendid coloured engravings. Many people have remarked on how millefiori looks just like sweets, so naturally if you make a mosaic of cakes and sweets using millefiori, it is clearly going to work!

Ramsgate Harbour

Smalti and handmade ceramic elements set in a metal tray
132.5 x 67.5cm (53 x 27in)

I relish the opportunity to work with other creative talents. Here is a mosaic made by me that is based on a painting of nearby Ramsgate harbour by Ramsgate painter, Bob Fludgate. Both painting and mosaic were recently exhibited in a joint exhibition of Cheek & Fludgate's work at the Marlowe Theatre in Canterbury, Kent, England.

Glossary

Andamento is a generic word to describe the general 'flow' of the mosaic – for example, the *andamento* of the Fruit Stool mosaic on page 64 is circular.

Direct method The most basic and common technique for the laying of mosaic. Tesserae are cut and stuck, face upwards, directly on to the base. The surface of mosaics made using this technique is therefore not always smooth and flat, and the shape and texture of the tesserae can vary enormously.

Indirect method A mosaic laying technique often used for large-scale work, and for pieces that need to have a smooth, flat, finished surface. Tesserae are stuck face down on adhesive film, or onto paper with a temporary, water-based bonding agent, generally gum arabic or wallpaper paste. The mosaic can then be transported if necessary, whole or in sections, and set in its permanent base with the film or paper side uppermost. The film or paper is then peeled away to reveal the finished work and the resulting surface is usually smooth.

Opus musivum This is a Roman mosaic technique in which the lines of the background follow the shape of the main mosaic motif. It literally means 'pertaining to the muses,' and is a wonderful term as it implies something that requires thought and creative judgment. A good example is the Dolphin Frieze on page 80.

Opus regulatum A Roman mosaic technique in which regular, square tesserae are applied in straight rows. The result is like a 'brick wall' pattern and was frequently used to fill expanses of background. For an example see Tea Time on page 124.

Opus sectile When a part of the mosaic consists of a single piece – such as the fishing boats in Ramsgate Harbour on page 125 – then this piece is known as *opus sectile*. If the whole area of the mosaic is covered in this way the resulting effect is more akin to stained glass or marquetry.

Opus tessellatum A Roman mosaic technique whereby regular, square tesserrae are applied in a rectilinear grid arrangement. The resulting uniform design was most frequently used to fill expanses of background.

Opus vermiculatum A Roman mosaic technique whereby regular, square tesserae are applied in a single row around the main mosaic motif to create a halo effect and emphasize the setting lines of the design. *Vermis* is the Latin word for worm, so you can think of this as the 'worm' of tesserae that outline the main figure. For an example see the Flamingo Side Table on page 102.

Tessera This is a Roman word meaning 'cube' – plural tesserae. These cubes are the basic building blocks of mosaic. The term embraces diverse materials, including marble, ceramic, glass, broken crockery, mirror glass, stones and pebbles.

Suppliers

UK

VIVAMosaics.com
12A Westcliff Terrace Mansions
Pegwell Road
Ramsgate
Kent CT11 0JD
Tel: +44 (0) 1843 581183
Web: www.vivamosaics.com
Email: sales@VIVAmosaics.com
Mail order supplier of materials and tools plus a range of Martin Cheek Mosaic Kits.

The Mosaic Workshop
Unit B
443-449 Holloway Road
London N7 6LJ
Tel: + 44 (0) 207 263 2997
Fax: + 44 (0) 207 272 2446
Web: www.mosaicworkshop.com
Retail mosaic outlet and workshops.

Oliver Budd's Mosaic Studio
Unit 5A, Crown Yard
Bedgebury Estate
Goudhurst
Kent TN17 2QZ.
Tel: + 44 (0) 1580 212643
Workshops and supplier of small marble tesserae and marble, will cut to order.

D.W & G. Heath (Croydon) Ltd
Hurst Place
Woldingham Road
Caterham
Surrey CR3 7LT
Tel: + 44 (0) 1883 652546
Large stockist of tiles by the sheet.

Edgar Udny & Co. Ltd
314 Balham High Road
London SW17 7AA
Tel: + 44 (0) 208 767 8181
Large stockist of tiles by the sheet.

Reed Harris Ltd
Riverside House
27 Carnworth Road
London SW6 3HR
Tel: + 44 (0) 207 736 7511
Large stockist of tiles by the sheet.

United Ceramic Tiles
Farleigh Hill
Tovil
Maidstone ME15 6RG
Tel: + 44 (0) 1622 757161
Bal flex, Fast flex, Ardipox PC Wall Adhesive, Ardex X7, bisque fired tiles.

Julian Coode Blacksmith
Nailbourne Forge
Court Hill
Littlebourne
Canterbury CT3 1TX.
Tel: + 44 (0) 1227 728336
Bespoke metal bases.

SJL Fabrications
Wingham Industrial Estate
Goodnestone Road
Wingham
Kent CT3 1AR
Tel: + 44 (0) 1227 720886
Metal trays and table bases for mosaics to measure.

Australia & N.Z.

Alan Patrick PTY Ltd
11 Agnes Street
Jolimont
Victoria 3002 Australia
Tel: +613 9654 8288
Fax: +613 9654 5650
Glass mosaic, marble, adhesives, grout.

Clay Art Studio
145c Cascades Road
Pakuranga
Auckland
New Zealand
Tel: +619 576 0327
Email: sales@mosaica.co.nz
Web: www.mosaica.co.nz
Tiles, mosaics, adhesives, grout.

Glass Craft Australia
54–56 Lexton Road
Box Hill North
Victoria Australia
Tel: +613 9897 4188
Fax: +613 9897 4344
Glass and vitreous mosaic, kits, adhesives, grout, tools.

Mosaic Madness
747 Darling Street (rear of building)
Rozelle, Sydney
NSW 2039 Australia
Tel/Fax: +612 9818 7471
Web: www.mosaicmadnes.com.au
Email:
getinspired@mosaicmadness.com.au

Courses

Martin & Arendse both run courses from their own studios:

Martin Cheek
Flint House
21 Harbour Street
Broadstairs
Kent CT10 1ET
Tel: +44 (0) 1843 861958
Web: www.martincheekmosaics.com
Email: martin@martincheekmosaics.com

Arendse Plesner
12A Westcliff Terrace Mansions
Pegwell Road
Ramsgate
Kent CT11 0JD
Tel: +44 (0) 1843 581183
Web: www.vivamosaics.com
Email: info@vivamosaics.com

Acknowledgements

With special thanks to Arendse Plesner, who developed the 'glass on glass' technique used for many of the projects in this book and whose input generally has been invaluable – not least as the hand model for all the step shots. Thanks also to Katie Cowan and Michelle Lo at Collins & Brown for supporting the book, Marie Clayton for her hard work on the text and Michael Wicks for all the wonderful photography.

Picture Credits

All project photography by Michael Wicks. Gallery images by Martin Cheek and Arendse Plesner.

Index